IMAGES
of America

CLEVELAND
SCHOOL GARDENS

Judy,
Best wishes

Joel Maden

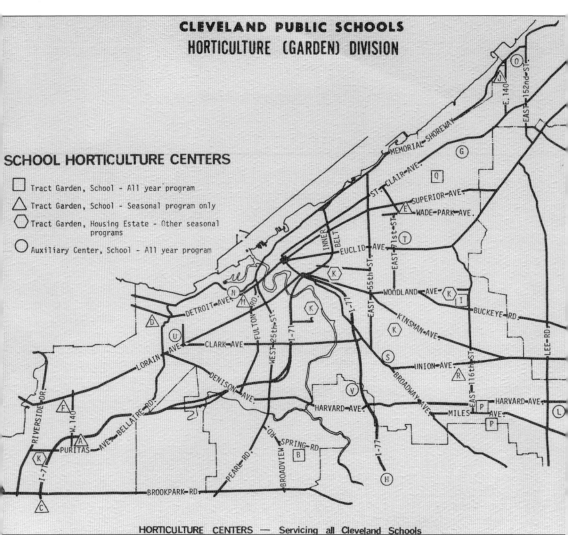

CLEVELAND PUBLIC SCHOOLS
HORTICULTURE (GARDEN) DIVISION

SCHOOL HORTICULTURE CENTERS

☐ Tract Garden, School - All year program

△ Tract Garden, School - Seasonal program only

⬡ Tract Garden, Housing Estate - Other seasonal programs

◯ Auxiliary Center, School - All year program

HORTICULTURE CENTERS — Servicing all Cleveland Schools

In 1969, there were 27 horticultural centers in Cleveland. The first organized center, or tract garden, was at Memorial School, located at 410 East 140th Street. The last center was the Dunham Tavern Museum tract garden at 6709 Euclid Avenue, which began in the early 1970s. Throughout the years, gardens were added and subtracted as schools were built or closed. Tract gardens were also located in housing estates, nursing homes, and at the Cuyahoga Fairgrounds. In 1978, the Cleveland Board of Education decided to close the garden program because of financial problems. (Cleveland Public Schools Horticultural Program Collection, Special Collections, Michael Schwartz Library, Cleveland State University.)

ON THE COVER: This little girl and boy are enjoying an early harvest of onions and radishes from their Miles tract garden plots in 1937. The corn is not yet knee-high, and the flower beds along the path are beginning to show signs of life. (Cleveland Public Schools Horticultural Program Collection, Special Collections, Michael Schwartz Library, Cleveland State University).

IMAGES
of America

CLEVELAND
SCHOOL GARDENS

Joel Mader

ARCADIA
PUBLISHING

Published by Arcadia Publishing
Charleston SC, Chicago IL, Portsmouth NH, San Francisco CA

Printed in the United States of America

Library of Congress Control Number: 2010924568

For all general information contact Arcadia Publishing at:
Telephone 843-853-2070
Fax 843-853-0044
E-mail sales@arcadiapublishing.com
For customer service and orders:
Toll-Free 1-888-313-2665

Visit us on the Internet at www.arcadiapublishing.com

To all the children who grew in body, mind, and
spirit in the Cleveland school gardens.

CONTENTS

ACKNOWLEDGMENTS

I would like to thank the following people for all their help and encouragement: special collections associate Lynn M. Duchez Bycko, M.A., and special collections librarian William C. Barrow, M.A., M.L.S., of Special Collections, Michael Schwartz Library, at Cleveland State University. I give a special thanks to Carolyn Hufford, who archived the Cleveland Public Schools Horticultural Program Collection. Her hard work did not go unnoticed. I want to thank my editor, Melissa Basilone, for all her help getting this book to print. I want to thank Joanne Scudder of Washington Park Horticultural Center for the original idea of this book. I am grateful to Charles Tuhacek, my good friend and colleague, for helping with the proofing of the manuscript. Lastly I wish to thank my wife, Jacqueline, a product of the Cleveland garden program, for her patience during this labor of love.

All images appear courtesy of the Cleveland Public Schools Horticultural Program Collection, Special Collections, Michael Schwartz Library, and Cleveland State University.

INTRODUCTION

For almost a quarter century, the Cleveland public school garden program was the most successful, innovative, and copied program in the United States. Horticultural educators came to Cleveland from New York to California—and as far away as Venezuela and Japan—to learn how to adapt the school garden concept for their cities. The pioneer program that began in 1904 as an idea to beautify vacant lots in the city bloomed into a multimillion-dollar horticultural program that touched every family of school-age children in Cleveland. The joy of gardening was taught from kindergarten to 12th grade. Each school in the system had a place set aside for garden activities. It could be just a small, fenced-in plot of dirt in the schoolyard, or it could be as large as a small gentleman's farm of 7 acres with a garden classroom building and multiple greenhouses.

These larger plots were called tract gardens. Garden science classes were a part of the curriculum. The science teacher was the garden teacher, and she or he would conduct lessons in the classroom and extend the lesson to a hands-on project in the school garden. In the second half of the 20th century, a vocational horticultural program for older students was established. This program prepared students for work and college in the fields of horticulture, earth science, and environmental science. In addition to the elementary and senior high programs, the board of education offered a two-year post-high school horticulture technology program, adult programs for homeowners, and special courses for employees of horticultural businesses.

The tract gardens were the gems of the program and the outward proof of their success. The largest tract garden was located on the east side of Cleveland in the old Slovak-Hungarian neighborhood of Woodhill and Buckeye Roads. Harvey Rice tract garden broke 7 acres of land for planting. Benjamin Franklin had 5.5 acres cultivated and today serves as a community garden run by the Old Brooklyn Neighborhood Development Association. Miles Elementary School boasted a sunken memorial garden, an herb garden, a historical log cabin, and 3.2 acres of tract gardens.

Schoolchildren rented individual gardens for a small fee. The rental fee was a real bargain; it paid for the plot, seeds, plants, fertilizer, and tools used. The tract garden season started in early spring and continued through the fall harvest. The plots were 6 feet by 10 feet for third graders, and up to 10 feet by 30 feet for senior high school students. Everything concerning the gardens was standardized, yet each individual superintendent was given license to be creative in his or her approach to learning. There were regularly scheduled programs throughout the season, and tract garden classes were scheduled after school. Summer classes were held twice a week when groups of 20 to 40 children would join in an activity. During the summer, each gardener had to cultivate, weed, and fertilize his or her plot. If a child neglected his or her garden for two weeks by being absent without permission, the garden was given to another student on a waiting list.

In 1969, some 92,820 students took part in garden activities. The home gardens (called victory gardens during World Wars I and II) added another 21,000 plots. In 1975, the last year of available records, the total value of the vegetables produced was $700,779 (not counting the worth of thousands of flowers grown). This was when a dozen ears of corn sold for a dollar.

The home garden program was a large part of the Cleveland school gardens. For students who lived far from a tract garden, home gardens were encouraged. Home gardens were treated like mini-tract garden plots, and all the rules of the larger tract gardens applied to them. Thousands of seed packages were distributed every year to students for home gardens. The home gardener would follow a set pattern for their plot and be graded on the success of the garden by a summer garden teacher. Twice each summer, teachers would visit, assist, and evaluate the gardeners. This contact with a teacher helped form a priceless bond between the family and the school.

The garden administration and science teachers were of the highest caliber. Teachers like Herbert Meyer, Paul Young, Luther Karrer, Dr. Peter Wotowiec, and Dr. Edward Johnson set a standard of excellence in horticulture that educators throughout the nation strived to attain. To this day, teachers like Joanne Scudder and the teachers of Washington Park Horticultural Center labor to keep the dream of the original garden pioneers alive. The administrators guided the elementary teachers through the garden curriculum. They published articles, books, and workbooks on gardening. Paul Young's *Garden-Graphs, Practical Instructions in Gardening* was an often-used textbook series on gardening. Because most of the upper elementary teachers had a limited background in plant science, the science classes were coordinated with a radio program presented by the board of education's own WBOE radio station. All the materials used in the broadcast (teacher's guides, seeds, and tools) were sent to the teacher beforehand. The students would follow and participate in the classroom lesson during the broadcast. This is probably the first use of broadcast radio–driven horticultural lessons for elementary students in the nation.

Each garden, large or small, had an open house, which parents would attend to view the progress of their child. These open houses featured parades, hot dog roasts, and games like scramble for peanuts and potato-bag races. Mini-awards assemblies would be held at each garden school, and the best vegetables and flowers were sent off to the annual all-schools awards assembly held in the fall. The annual horticultural assembly was held at the Higbee department store auditorium for years. From the 1960s through the 1970s, the awards were presented at the Cleveland Botanical Gardens. The children received certificates, ribbons, plaques, and trophies for the years served in the garden, for excellence in flowers and vegetables, vegetable caricatures, garden poster design, and garden essays. The highest garden award was the Agricola. This award was given to the very best gardeners with the longest time served in the tracts. The awards assemblies attracted the administrators of the system and the local and state politicians, each of whom gave a speech. The assemblies would include the all-city band and a set agenda of music, speeches, and awards. The gardeners were listed in the awards program by school or award given. The programs opened with the pledge to the flag and ended with a national patriotic song.

The Cleveland school garden program began to wind down in 1977. The closure was caused by an ever-growing budget deficit in the last years of the 1970s, which meant less money for established programs. One of the first programs to be closed was the Cleveland school tract garden program. This was no surprise for the board. For years, political activists were questioning the worth of programs like adult education and the garden program. It was when the board had no choice that it decided to cancel the garden program.

One

SCHOOL TRACT GARDENS

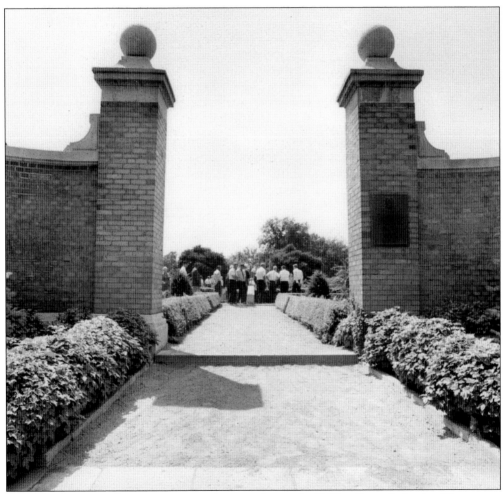

The school tract garden program started on a sad note. In 1908, a fire at Lakeview Elementary School in Collinwood (incorporated into Cleveland two years after the fire) killed 172 children, two teachers, and a brave rescuer, resulting in the construction of a memorial garden on the site of the fire. The Memorial Elementary School garden, at 410 East 152nd Street, became a living memorial.

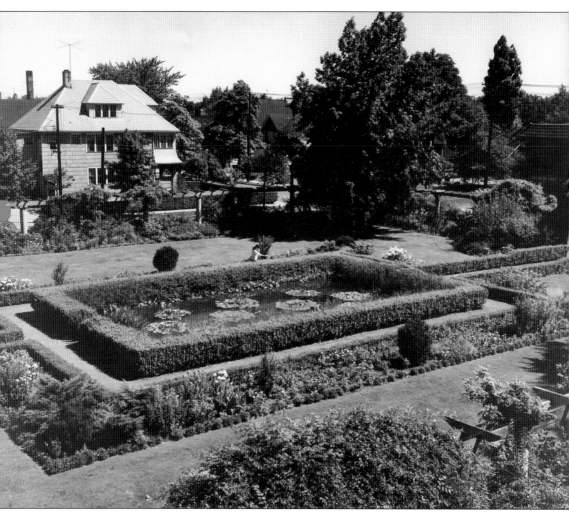

The memorial garden of the Lakeview Elementary School was cultivated on the spot of the original school, the scene of the worst school fire disaster in the country. Some of the children were so badly burned that they could not be identified and were buried at Lakeview Cemetery, which today is considered a historical outdoor horticultural garden and museum. The new Memorial School was erected right next to the memorial garden. The upgrade of fire safety codes and fire drills were a direct result of the tragedy. Although the Home Garden Association began a partnership with the Cleveland Public Schools around the late 19th century and is credited with the cleaning up of alleyways and the beautifying the yards of residences, it was the Memorial Garden that became the foundation for the schools' first organized horticulture program.

The scene at the fire was chaos. Parents were only a few feet away from their children but could do nothing. The children died right in front of their eyes. Children were piled like cordwood at the rear exit of the school. Parents would reach in and try to pull the dying out of the flames. The janitor, who lost three of his own children, was found innocent in a trial. It was ultimately determined that a steam pipe ignited a wooden beam in the basement of the school. Survivors of the tragic fire, pictured here, had a reunion on April 27, 1965. School property laid aside specifically for memorials and garden cultivation was a concept that had its beginnings at Memorial School. As the century went on, the idea of introducing plant science to the elementary school student curriculum was adopted. It was not long before the tract gardens started at other elementary schools.

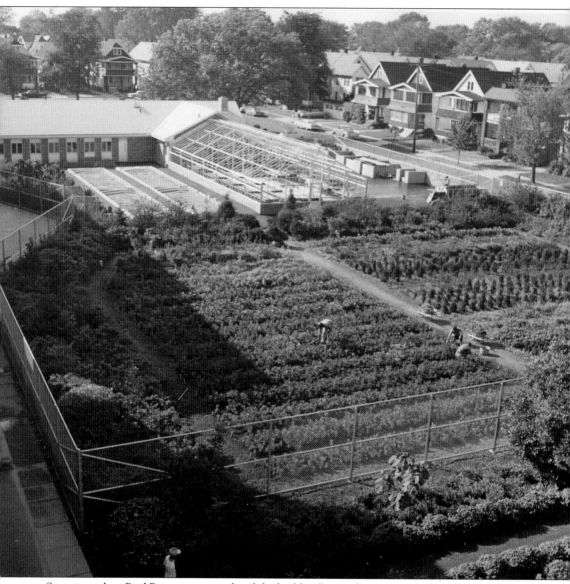

Superintendent Paul Briggs was considered the builder. During his time as the head of the Cleveland Public Schools, he built many new high school and elementary buildings. The school gardens were one of his favorite choices for renewal. Briggs would attend every award program and kept a line-item budget for the school gardens. In the late 1970s, when he saw the across-the-board-cuts that needed to be made, he decided to retire and let another person thin the programs. He always said, "The difference between just an ordinary school system and a great one is the ability to organize and implement outstanding, innovative programs. I know of no project more important than the school horticulture program." At Memorial School, he had constructed a garden classroom and a new greenhouse. In this photograph, dated October 3, 1966, the greenhouse is not yet finished. Notice the building materials in the upper corner next to the greenhouse. The shrub garden is directly in front of the complex.

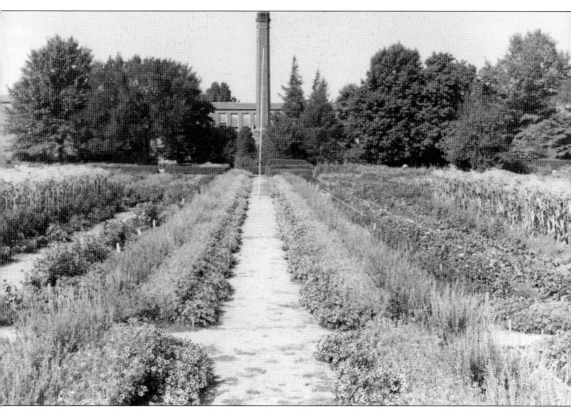

The Benjamin Franklin tract garden, located on 1905 Spring Road, was one of the larger tract gardens. It boasted 6.5 acres and was also one of the longest lasting of all the original public school gardens. "Ben" was an all-season facility for grades 3 through 12. It had spring-season plots for kindergarten and primary school pupils, as well as sight-saving, blind, and crippled pupils. The tract is now a community garden run by the Old Brooklyn Neighborhood Development Association. The permanent garden design was of Asian construction. Harvey Rice garden (7 acres) and Miles Elementary School garden (3 acres) were the other two large tracts in the city. The first superintendent of Benjamin Franklin was Karl J. Koop, who began at the tract garden in the latter half of the 1920s. He contributed a great deal to the tract garden program, not only in Cleveland, but also in other cities that copied the Cleveland program. His philosophy and many of the techniques he developed back in the 1920s were still practiced into the 1970s.

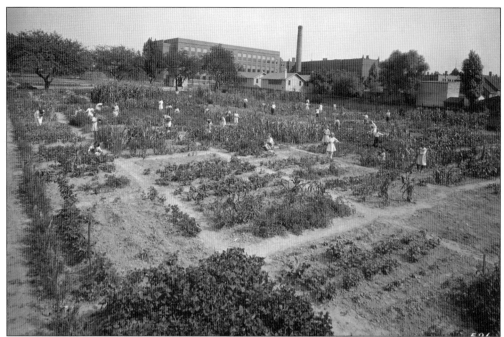

The board of education bought 11 acres of land from a private farmer who owned Boyert Farm. The farm was divided into two parts: 5.5 acres for a school and 5.5 acres for a garden. The purchase of this land in 1922 began the history of Benjamin Franklin School and the Benjamin Franklin tract garden. At first, the garden was cultivated as a nursery. Plants were grown to beautify schools in the neighborhood. The school was built in 1923 and was both a junior high and an elementary school. Individual garden plots became popular, and children from both public and parochial schools were allowed to rent a plot. The c. 1927 photograph above shows the gardens sectioned into smaller individual plots. The image below, taken earlier, shows a student cultivating the ground with a hand tiller.

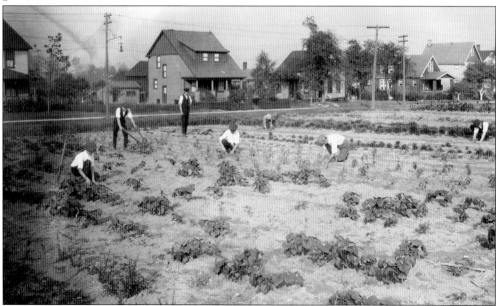

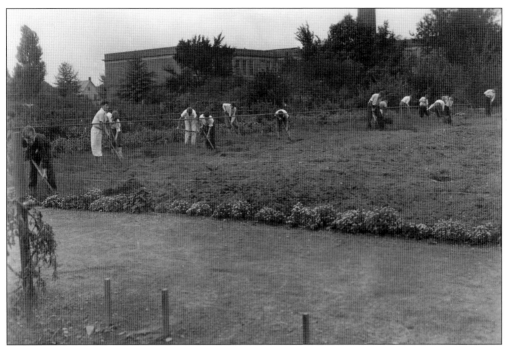

In the early years of the Benjamin Franklin garden, in the days before rototillers and garden tractors, all work was done by hand. The all-male crew, some in knickerbockers, would toil until the whole garden was turned. The rows are already strung in this photograph, and the flowers along the main path are blooming, indicating that it is early spring. The staking of parallel rows to the main path is a definite sign that Superintendent Koop had planned this garden. The Koop plan was carried over to all the gardens in the system and used until the closing of the gardens in the late 1970s. Recycling of vegetation in a compost pile was practiced at every tract. Some students had the lucky job of watering and turning the compost pile once a month.

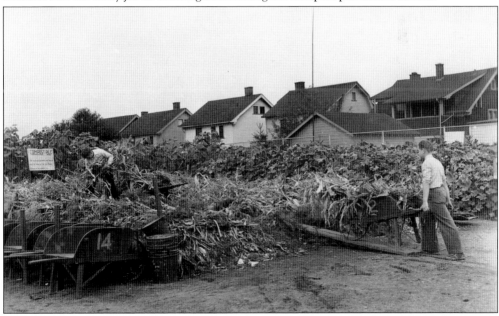

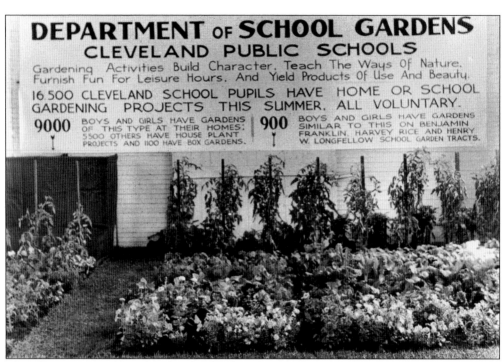

This advertisement was used at the Cleveland Home and Flower Show, where the Cleveland Public Schools' horticultural department always had an exhibit. The numbers in the photograph above do not include the tracts in the housing projects, the Dunham Tavern Museum, the Eliza Bryant Nursing Home, the Cuyahoga County fairgrounds, and the hundreds of flower plots around the school buildings throughout the system. The picture below shows a typical tract garden display that was exhibited at the Cleveland Home and Flower Show that was held every year in January. The exhibit lists Jack Durell, Nick Paserk, and Ida Yetra as the garden teachers. These are people who had a long history with the tract gardens. The job classifications would change over the years, but the one constant was that the classroom teacher was licensed by the State of Ohio.

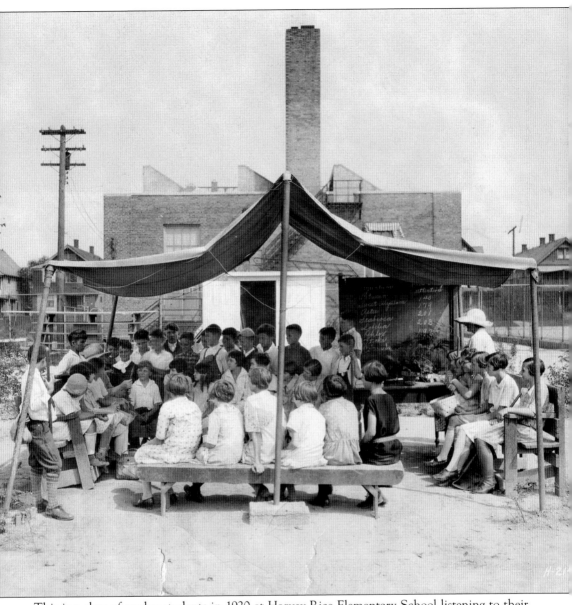

This is a class of garden students in 1920 at Harvey Rice Elementary School listening to their teacher (who is seated fifth from the left). The gardeners are in their school clothes. Quite often the science teacher would take the students out to the tract garden behind the school to teach a lesson in botany. The canopy was used to protect the students from the early June sun. On Saturdays and during the summer months, the garden students, usually a group of 40, would come together to discuss specific problems with the teacher or garden superintendent before they went into their individual plots. Harvey Rice Tract Garden was the largest of all the tracts, with over 7 acres under cultivation. The garden was located at 2916 East 116th Street. The tract had woodland plantings, a picnic area, and an outdoor auditorium. The main garden building and greenhouse were built 40 years later.

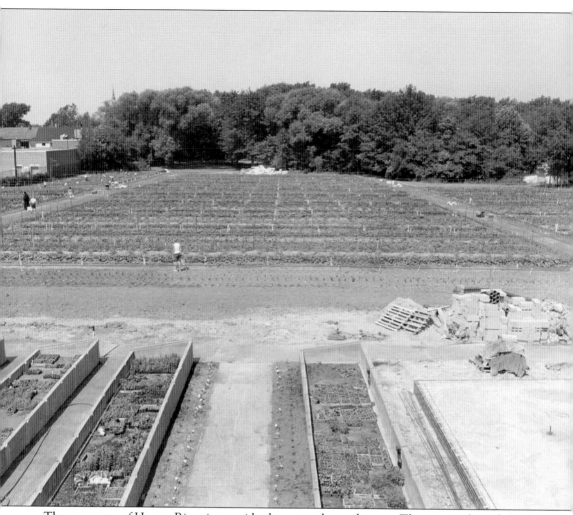

The panorama of Harvey Rice gives an idea how vast the garden was. This picture from the early 1960s shows how neatly each student garden was sectioned. The cold frames with flower beds next to them illustrate how every bit of garden space was used. On the right, the foundation of the new greenhouse is finished and ready to be built upon. To the upper left is a class of parochial students under the watchful eye of a Notre Dame nun. The Notre Dame sisters taught at nearby St. Benedict Elementary School. The area around the garden was populated largely by Slovak and Hungarian Catholics. The Cleveland Board of Education allowed Catholic school students to garden. The rule was if a child was able to walk to the garden, she or he could have a tract garden. The garden was a block away from the neighborhood picture show theater called the Regent. On Saturdays the kids would first check out their gardens and then go to the movies.

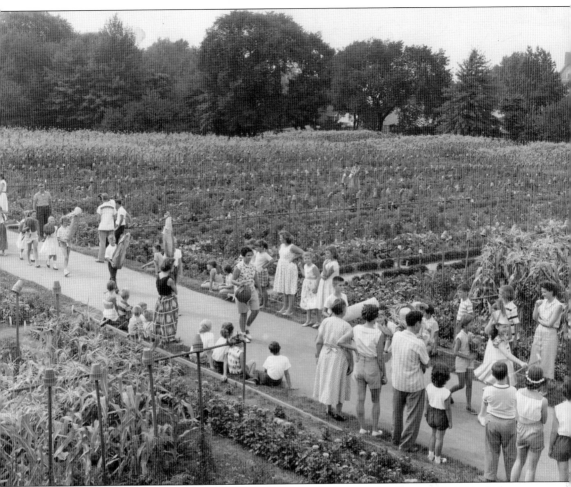

Open house day at Harvey Rice tract garden started with the parade of vegetables. The kids are carrying papier-mâché tomatoes, corn, beans, and peppers. A majorette leads the parade with a baton and tall-feathered hat. The proud parents are lined on either side of the main garden path. This photograph gives a good view of the size of the garden. A gardener and his mother are all but lost in the upper right center of the tract garden. The woods in the back were a special place for wiener roasts. In the front left of the picture is the overhead watering-pipe system. On the end of the pipe, blocking the head of the youngster sitting down, is a shutoff valve for that section of the garden. The City of Cleveland did not charge the schools for water. One of the jobs for the school janitor was to keep the watering system in good shape.

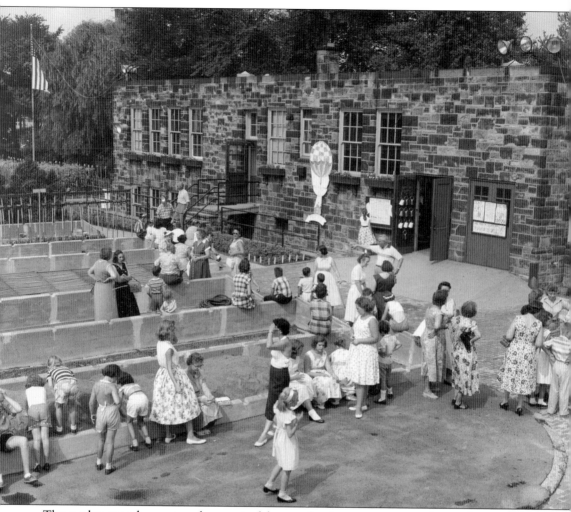

The garden open house was always a joyful event for the young tract gardeners. It was a time to show off to their parents the hard work they did all summer long. Nothing speaks more to the times than this 1954 picture. Beside the male garden teachers at Harvey Rice, one would be hard pressed to find fathers of the gardeners in this photograph, as they were away at work. The mothers, in their summer dresses, were the ones who attended the open houses. This photograph clearly shows the garden classroom that was built in 1939. Notice the floodlights on top of the building. Garden safety was never much of problem until the late 1970s and early 1980s. The cold frames are made of poured concrete—much different than the wood construction in most tract gardens. Utilizing every bit of space, the students planted a flower garden in front of the back door of the classroom building. The area of the flagpole on the left is the future space of the new greenhouse, built in the early 1960s.

The above photograph is the Crawford Memorial Garden at Harvey Rice. St. Luke Hospital's roof towers shine in the bright sun. St. Luke Hospital serviced the southeast area of Cleveland and Shaker Heights, one of the richest cities in the nation. Many of the gardeners were sent to the emergency room at St. Luke for minor injuries in the garden. The water fountain at the far end of the photograph was the favorite drinking fountain of gardeners. The garden plan at right was the intermediate plan for those children in the upper elementary and junior high school. The following is the note to the parents found at the bottom of this plan, "This garden is suited to the ability of your child. In selecting the crops, careful consideration was given to the best for home use, the size of the plot, the kind of soil, and our climate."

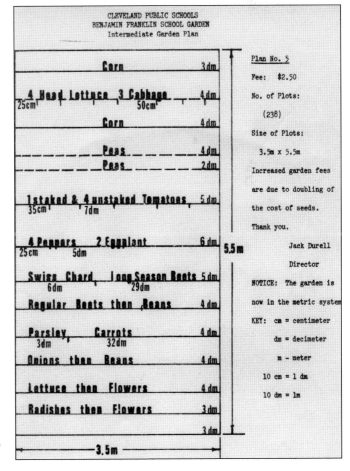

CLEVELAND PUBLIC SCHOOLS
BENJAMIN FRANKLIN SCHOOL GARDEN
Intermediate Garden Plan

Corn	3 dm
4 Head Lettuce 3 Cabbage 25cm 50cm	4 dm
Corn	4 dm
Peas	4 dm
Peas	2 dm
1 staked & 4 unstaked Tomatoes 35cm 7dm	5 dm
4 Peppers 2 Eggplant 25cm 5dm	6 dm
Swiss Chard Long Season Beets 6dm 29dm	5 dm
Regular Beets then Beans	4 dm
Parsley Carrots 3dm 32dm	4 dm
Onions then Beans	4 dm
Lettuce then Flowers	4 dm
Radishes then Flowers	3 dm
	3 dm

3.5m

5.5m

Plan No. 5

Fee: $2.50

No. of Plots:

 (238)

Size of Plots:

 3.5m x 5.5m

Increased garden fees

are due to doubling of

the cost of seeds.

Thank you.

 Jack Durell

 Director

NOTICE: The garden is

now in the metric system

KEY: cm = centimeter

 dm = decimeter

 m = meter

 10 cm = 1 dm

 10 dm = 1m

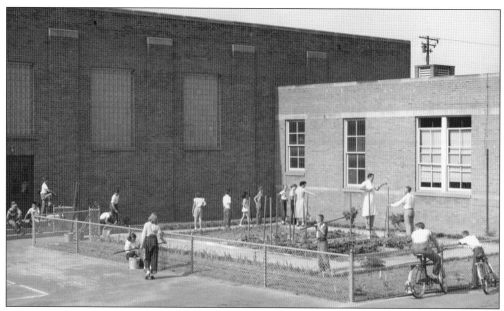

A tract garden could be as small as 10 feet by 20 feet, as illustrated by the garden at Artemus Ward Elementary School, located at 7901 Halle Avenue. The horticultural department encouraged planting in any available space. There never was any competition between gardens about who had the largest tract. The quality of the vegetables and flowers was what set the gardens apart.

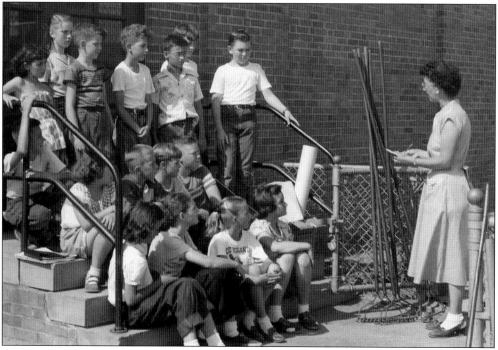

The teacher at Artemus Ward was as serious about her small tract as any tract teacher in the system. Although this garden was formed out of a piece of ground surrounded by asphalt, the students could be just as proud of their garden as any larger plot. The teacher is taking attendance, and the rakes are readied for the workers. Next to the girl on the far right is the box of seed packets.

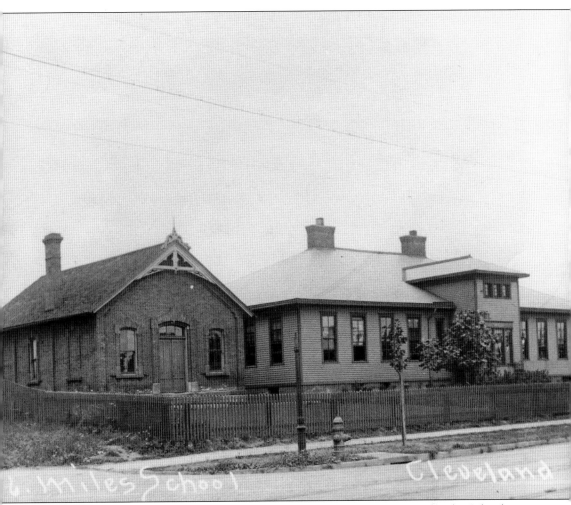

Miles tract garden was located across the street from the school. The original Miles School was a redbrick building at the corner of Miles Avenue and East 120th Street—a typical one-room schoolhouse. As the community grew, a frame building was erected next to the brick building. In 1940, the buildings were razed and land became available for a tract garden. At first the board developed a plan to build a playground on the site. When the parents read about this, they went into immediate action. They succeeded in getting the "playground" cancelled, the land to be kept, and a school garden tract to be developed. As the years went on, more land became available. There was land behind the homes on East 120th Street that was landlocked. The owners had no access to this land from either East 120th Street or from Miles Avenue. The owners sold the land to the Cleveland Board of Education, and the garden was extended.

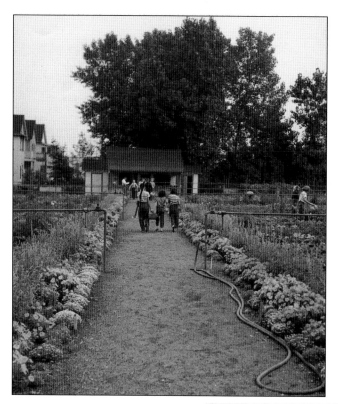

Miles tract garden was located at 12017 Miles Avenue. This early-1960s photograph shows the paltry garden house and the extensive above-garden watering system. This storage shed was donated by the local Kiwanis Club and moved to Cleveland from a Scout camp in Chagrin. There was no floor in the building except natural dirt. During heavy rains, water ran into the building.

The watering system, with its fill pipe extended down and its hose faucets spaced in the main path, could water the whole tract. Filling a pail full of water was a job for two gardeners. The watering can held about 2.5 gallons of water and was used to water individual plants. The garden as a whole was watered with a hose as needed. The cans were all numbered, as were the tools, and each individual student was responsible for his or her tools.

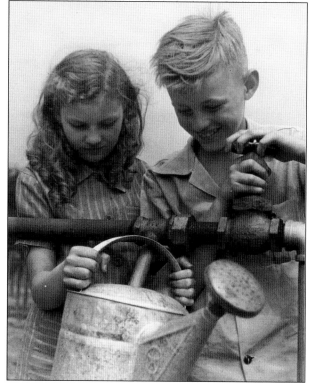

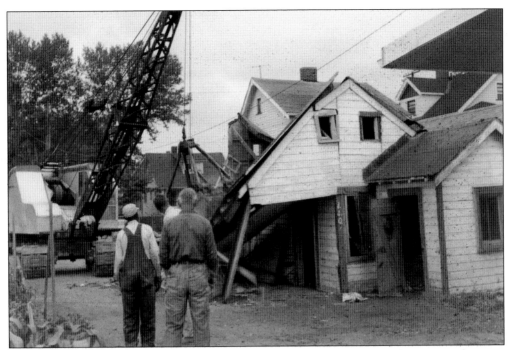

The old garden building was demolished in August 1962. The new garden classroom and storage building was erected right next to the old building. (Notice the overhang of the new building in the upper right-hand corner of the photograph.)

After a battle with the city and a construction company in 1964, Miles garden was able to acquire 2 acres of land that could accommodate 175 to 200 young summer gardeners. Before the addition of the land, Miles had 500 plots. Youngsters from 15 schools, including some parochial schools, cultivated plots on the tract. The ribbon-cutting ceremony for the new horticultural classroom building was in October 1962. The Miles garden superintendent is leading the way.

Jack Durell was the keynote speaker for the ceremony for the new classroom. He related the history of the garden, telling of the struggles to form a tract garden. He told how, in 1940, two neighboring schools absorbed the junior high pupils, and that the original Miles School was razed, leaving land for cultivation. He told how there was a question concerning the sale of the land, which was wanted by local businesses. The board answered that the land was restricted for educational purposes only. The fight was worthwhile, as evidenced by the smiling faces of the youngsters with their harvest baskets walking next to the new building.

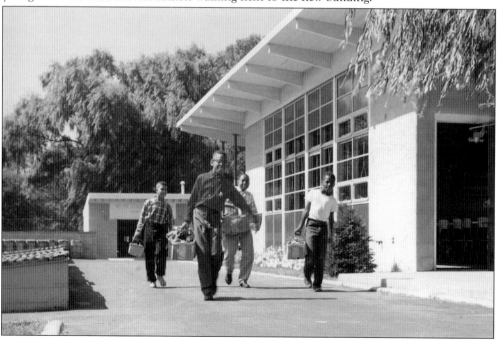

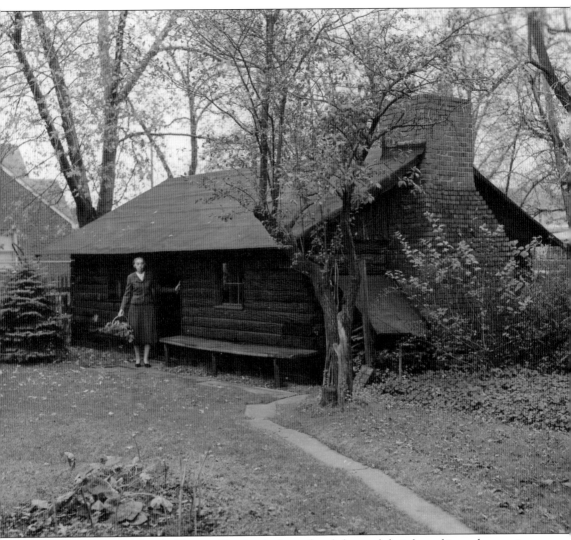

In 1963, the Zverina family (Frances Zverina is shown here) donated their log cabin and property to the Cleveland Board of Education. Herbert Meyer, directing supervisor of the horticultural division, decided to make an herb garden at the cabin. Henry Pree, an eminent Cleveland landscape architect, magnanimously designed the garden. Jack Durell, the director in charge of the Miles School garden tract, Nicholas Paserk, the garden superintendent, and numerous student assistants devoted their efforts and time in developing it. Durell collected and planted herbs as well as common and rare trees and shrubs. It had become an herb and botanical garden, and over 180 members of the Herb Society of America visited it. Frances Zverina became involved with the gardens throughout the remainder of her life. She would be photographed along with other garden teachers and administrators. This is a photograph of the log cabin in its primitive state.

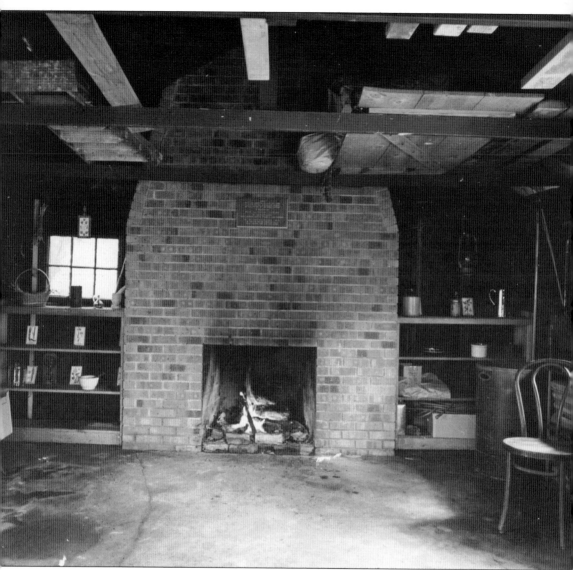

The log cabin was a playhouse for the five children of the Zverina family, whose father built it around 1908. In the words of Frances Zverina, "He built a fireplace at one end and provided space in the chimney for smoking meat. At the opposite side he fashioned a U-shaped inlaid table with benches. About 25 persons could gather around it. In those days, the rawhide latchstrings were always hanging out. Relatives and friends came in the summer to pick daisies in the fields and have a picnic in the log house. There were wiener roasts, chicken fries, and clambakes, too. At night, coal oil lamps added their yellow flame to the fireside glow. In the winter, the succulent cottage hams and bacon were smoked." The Zverina children—Rose, Andrew, Justin, Frances, and Robert—attended Miles School and had home gardens. Years later, the sisters, who still lived in the family homestead in view of the lavish school gardens, became patrons of the school garden program and annually awarded silver dollars to the best gardeners.

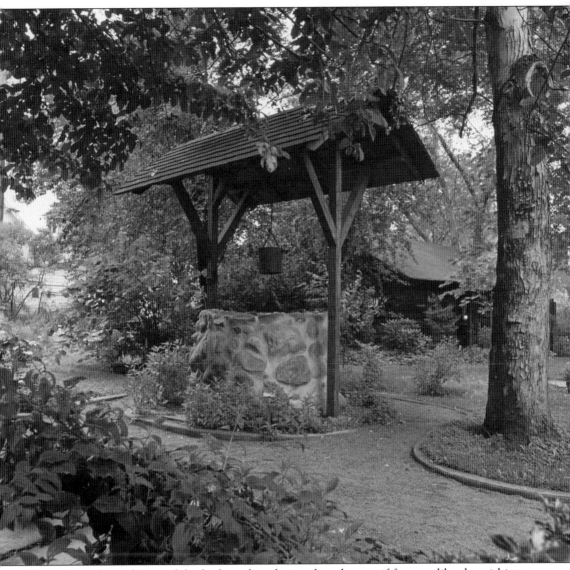

Henry Pree, the architect of the herb garden, designed garden motif features like the wishing well, the water pump, the lily pad, and sundial. Around these features was a path brimming with small herb gardens. Frances Zverina recalled, "The cabin was built in an old apple orchard. The flavor of the apples was as delightful as the names of the varieties, which included Maiden Blush, Belmont, Queen Anne, Pumpkin Sweet, Golden Sweet, Russet, Twenty Ounce, Greening, Sheep Nose, and Seek-No-Further. A few old-fashioned pear trees grew among them, some with very slender trunks and three of gigantic girth. There were some plum trees, and a sweet cherry, too, and farther away, stately honey locusts." It was due to the vision of the Zverina family and their initial contribution of the log cabin and support of the new garden building that Miles garden grew so rapidly in the 1960s.

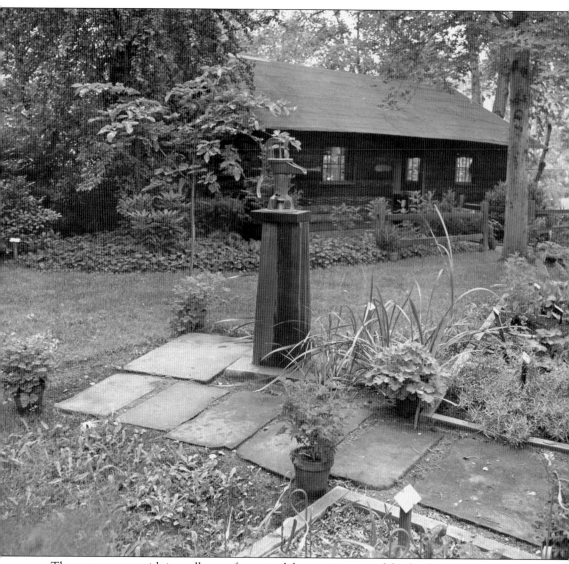

The water pump, with its walkway of granite slabs, was just one of the focal points in this garden. Zverina related, "Along the back of the log house, a few herbs grew in a little garden, enclosed by a lath fence. There were wormwood, veronica, violets, parsley, dill, leek, chives, and hollyhock, and nasturtiums climbed over the garden gate. Outside the fence grew horseradish and sweet flag root, and mints spread along the wet-weather brook. A long hedge of elderberries bordered the pasture beyond. Here in the pasture and woodland, mushrooms and wild herbs were to be found. The tangy fragrance of the pennyroyal always rose up as a happy surprise when trod upon." To acknowledge all that the Zverina family did for the Miles schoolchildren, the new horticultural building was dedicated to the memory of Rose Zverina.

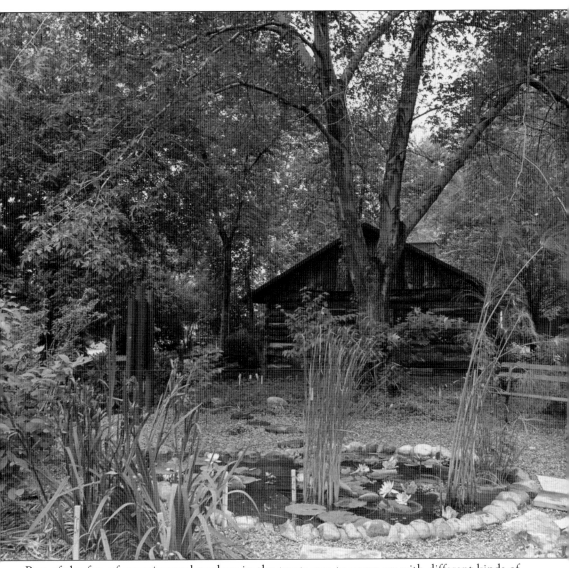

Part of the fun of experimental gardens in the tracts was to come up with different kinds of flowers. A few home gardeners would construct ponds in their backyards. What are called water treatments today were then considered exotic in an urban setting. Henry Pree included a water lily pond next to the cabin. Continuing the history of this piece of earth, Frances Zverina revealed, "This southeast section of Cleveland had been settled earlier by New Englanders. A few of their farmhouses stood in the area. Twelve families, who had followed in the wake of Moses Cleaveland, came over the mountains from Connecticut to colonize this part of the Western Reserve. They each bought 50 acres of land for $4 an acre from the Connecticut Land Company. Before their coming, this had been the happy hunting grounds of the Indians. By the time the Zverina family bought acreage from the Connecticut settlers, the Indian campfires had long been extinguished. But gypsy encampments appeared each year. Sometimes the gypsy children attended our local school, Miles School."

In March 1964, Jack Durell supervised the growing of more than 80 different herbs for the home and flower-show setting. These herbs were variously started from seeds and cuttings. Some were gifts from Frances Zverina, then an active member of the Western Reserve Herb Society. Jack Durell recalled, "There was no budget set aside for it by the board. It (herb garden) was written up in the Brooklyn Botanical garden Bulletin. It was visited by over 180 members of the Herb Society of America. . . . There was the visit by the blind children who could squeeze and sniff the plants and thereby relate to them . . . I knew that the efforts were all worthwhile." Pictured above are a group of visitors from the Herb Society of America. The photograph below shows how close "civilization" was to the pioneer cabin's property.

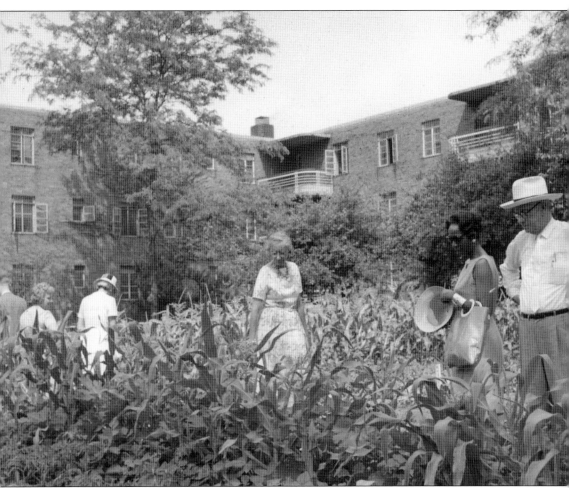

Tract gardens at housing estates were a big part of the Cleveland school garden program. The housing authority, established in 1933, was created to improve housing for the less fortunate and to eliminate slum areas. The urban renewal programs of the 1950s and 1960s razed many single- and multifamily houses in the inner city. Pictured is the Cedar Central Estates. After the homes were built, usually multifamily units, there was space for large tract gardens. The residents of the estates would learn elementary garden practices from the Cleveland school's garden teacher. These sites were full-season pupil plots, grades 3 to 12. The garden department had tracts at various housing sites. The sites were Cedar Central, Garden Valley, Riverside, Valley View, and Woodhill. The total land of all the gardens was 2.3 acres.

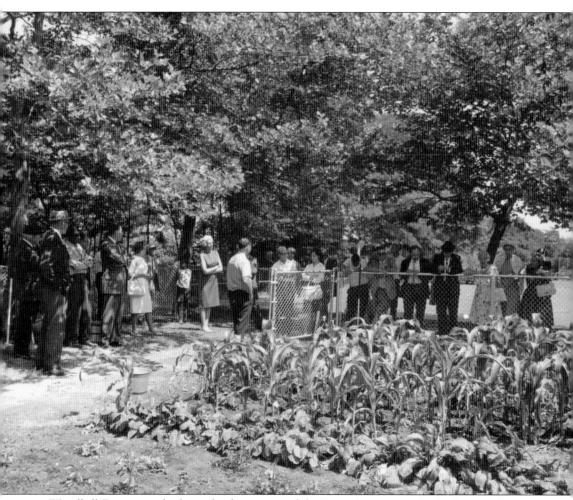

Woodhill Estates was built on the former site of the Luna Amusement Park. Groups of visitors from as far away as California would come to study how Cleveland put mini-farms next to large housing estates. Luna Park, which sat on 35 acres between 110th Street and Woodhill Road, was called a "fairyland" because of its architecture. The creator of this park was Fred Ingersoll, who was famous for building of amusement park rides. The big draw of the park was the sale of beer. When Prohibition came to Cleveland, Luna Park declined rapidly and finally closed its gates in 1930. Soon after the closing, the housing act set the stage for low-cost housing on the park site; the gardens followed. Legend has it that on a clear night the housing residents could hear the ghostly screams of kids on the rides of Luna Park.

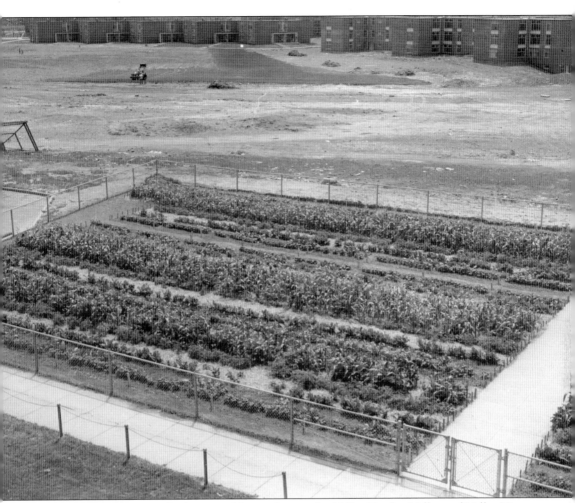

Two more housing estates broke ground for gardens in the 1960s, Garden Valley and Valley View. Garden Valley Estates was located at Seventy-Ninth Street and Kinsman Road. The photograph shows the standardized garden plan, with staked rows set out just like the school tract gardens. In the late 1970s, Garden Valley's home school was South High School on Broadway Avenue, which had a greenhouse and plant classroom laboratory on its roof.

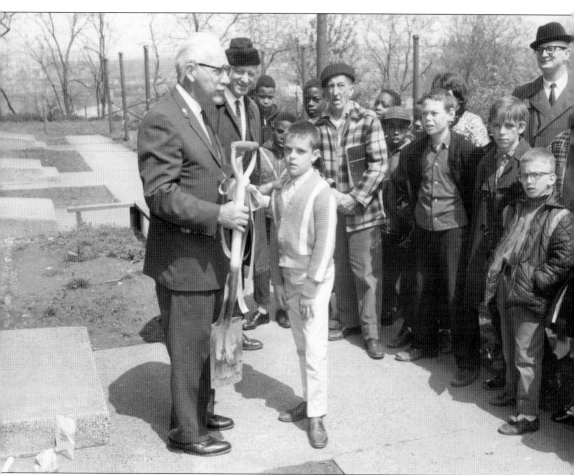

Breaking ground at the Valley View Housing Estates was a quiet happening. Unlike some of the larger tracts, when the media would come out in force, just a few of the garden staff came for this opening. Herbert Meyer, the Cleveland garden supervisor, hands a shovel to a lucky student chosen to break the ground. Behind Meyer are seed packs ready to be planted.

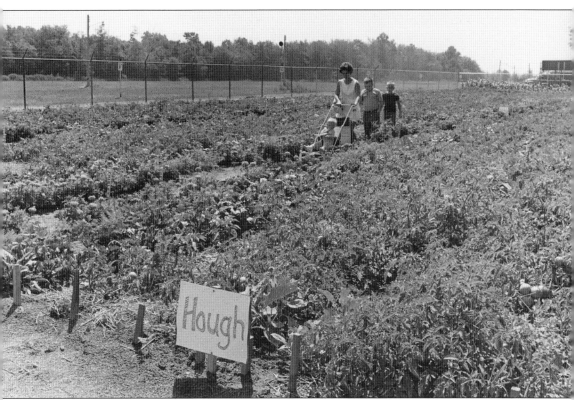

Paul Young was the supervisor of the gardens for many years. He was also associated with the Cuyahoga County Fair for a long time. The fairgrounds are surrounded by urban sprawl. The fair was the only exposure that inner-city children had to experience farm life, so it was natural that Young extended the tract garden concept to the Cuyahoga Fair. The students from different neighborhoods would take a bus to the fair garden. Each neighborhood had a tract set aside for their garden. Pictured is the Hough neighborhood section of the garden. Throughout the history of the county fair, the horticultural teachers played an important part. The fair was held in August each year. The tract gardeners had another venue for showing their crops, and ribbons were given for the best vegetables.

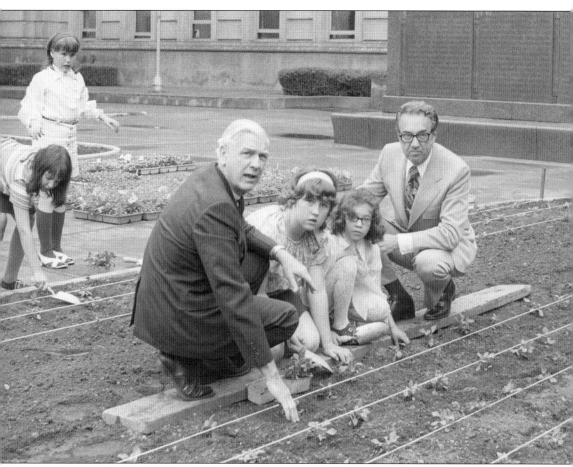

The mayor of Cleveland, Ralph Perk (1972–1977, far right), and the deputy superintendent, George Theobald (left), are helping young gardeners at the Cleveland Board of Education headquarters. The board had a tract garden behind its building right under the statue of Abraham Lincoln. The board of education building backs against the Cleveland Mall and had plenty of green space for a garden. The mayor and superintendent are helping tend the spring crop. The grounds of "Headquarters" were maintained by the garden program. Students would come by school bus or private car to plant flowers around the building. Later in the history of the Cleveland board, the city would take complete control of the educational system. By the time the city took over the system, the tract garden program was ended. As an added touch, Washington Park Horticultural Center would send cut flowers to the superintendent's office once a week.

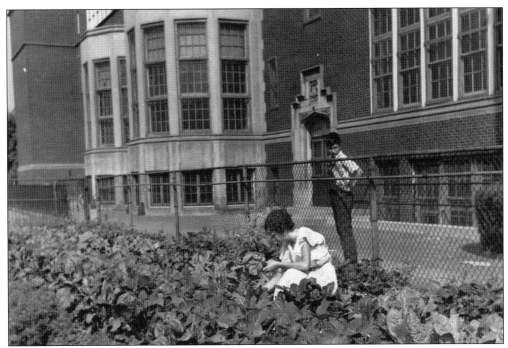

Almira (above) and Crispus Attucks Elementary Schools were typical of what the horticultural department considered "greening all the schools in the system." Almira, located at 3575 West 130th Street, was built in 1916. The garden shown in this 1937 photograph is a well-developed tract. The garden of Crispus Attucks students was the space along a walkway to the school. Many times the classroom lesson was transferred outside the school on any available ground. In many cases, the outdoor classroom around the school was the only exposure to nature for inner-city children. Through the years, the horticultural department changed plans to accommodate the different needs of each school. Crispus Attucks is no longer open.

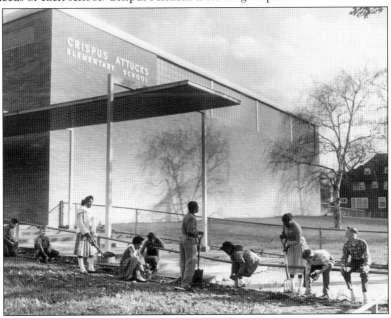

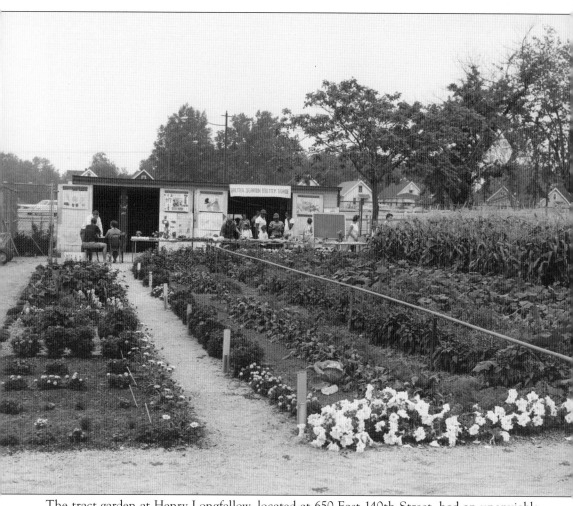

The tract garden at Henry Longfellow, located at 650 East 140th Street, had an unenviable location right next to I-90, the Lakeland Freeway. The noise of the freeway could be deafening at times, but it did not seem to bother the gardeners or their plants. The 1.2-acre tract, seen in this 1965 photograph, was an all-season garden for grades 3 to 12. It also had spring-season plots for kindergarten and primary pupils and blind and crippled pupils. For a few years before the closing of all the gardens, officials had hoped to institute gardens for the handicapped. They were also hoping to include in the annual garden fair a division for handicapped children. Schools like the Sunbeam School for Crippled Children at 11731 Mount Overlook Road in Southeast Cleveland would often partake in garden projects around their school. The sign above the garden house reads "D-Better D-Garden D-Better D-Grade."

This sign in this 1967 Longfellow garden explains many things about a typical Cleveland public school tract garden. First there was a garden show, which was probably a skit the students put together for their parents. Then the garden had a mini-garden fair, with the judging of the vegetables and flowers. Finally, perfect attendance and excellent grades in school, not in the garden, were rewarded at an in garden awards ceremony.

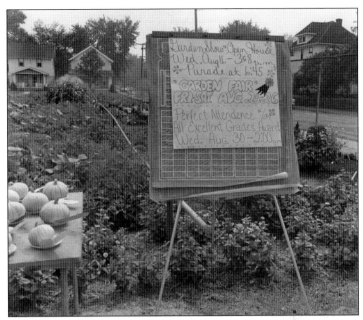

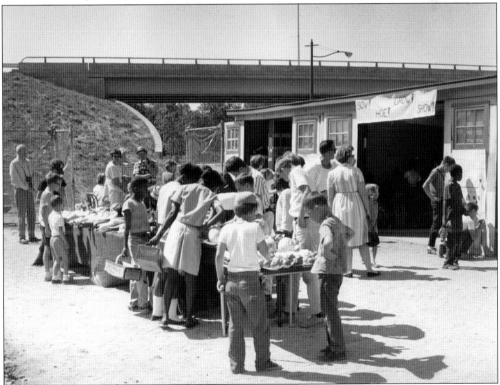

This 1964 photograph shows a clear view of the I-90 overpass. The pupils are checking their grades at the Longfellow open house. Les Beamish, one of the garden administrators, is the man to the far left. He was the official garden photographer toward the end of the tract garden program. The ubiquitous Beamish would show up at all tract garden events. The sign above the garden door reads "Sow! Hoe! Grow! Show!"

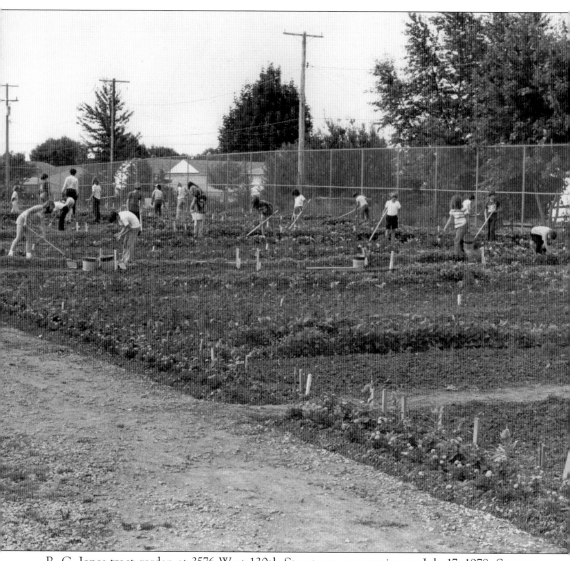

R. G. Jones tract garden at 3576 West 130th Street was very active on July 17, 1978. Summer tract students are fast at work weeding and hoeing. The students have arrived in their garden as a group and at a certain time of the day. Other children have either come and gone or will be coming soon. The tracts were on a set schedule. Obviously no corn was planted. The rows are perpendicular to the main path; this is a deviation from the main plan to save space. The buckets the pupils are using were painted with a red stripe to discourage theft. This is the first weeding since school ended. The tallest person (at left) is probably the garden teacher. One thing for sure is that these kids are not bored on their summer vacation.

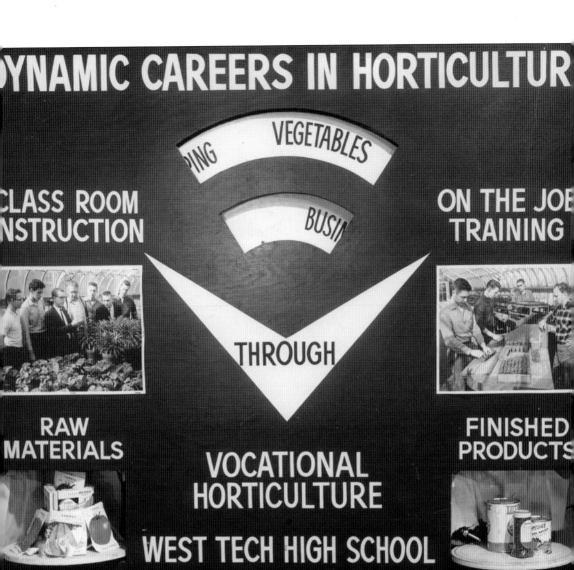

West Technical High School was a vanguard of vocational education. One of the programs that remained throughout the history of the school was the vocational horticulture program. This hands-on poster was one way to advertise its program at the Home and Flower Show. At the beginning of the 20th century, vocational education was desperately needed for the students planning on entering the workforce immediately after graduation. The National Register of Historic Places notes, "West Tech once featured the largest school greenhouse in the United States, and the only vocational horticulture program in Cleveland." The school offered the first auto driving classes, aeronautics/aircraft classes, and metallurgy classes. An interesting side note is West Tech had the first school radio transmitter in the world.

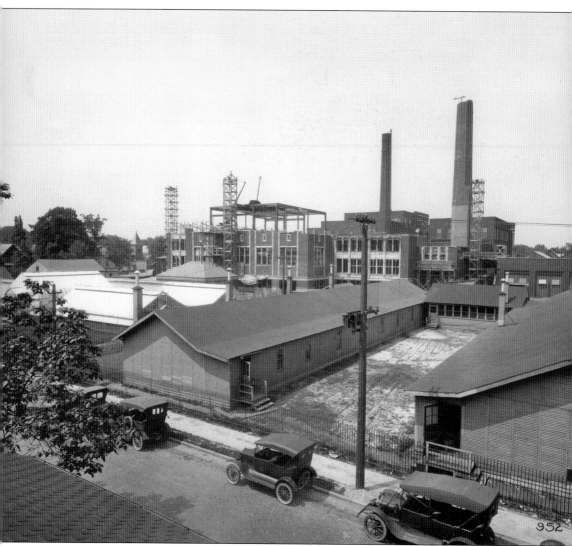

West Technical High School opened its doors in February 1912. Within a few years, it became evident that the school needed to be expanded. An addition was started in 1922 and finished in 1924. This view shows the scaffolding and crane erecting the addition on the west side of the main building. Temporary classrooms were built to accommodate the bulging enrollment. A one-story gabled garden building and three greenhouses (shown on the left) were constructed to support the horticultural program. West Technical was the largest high school in the state, with at an enrollment of 4,479 students in 1938. During this time, major cities were observing, with the thought of duplicating, the Cleveland school system's experimental vocational horticultural program. The greenhouses were replaced with new ones in the 1960s, only to be demolished in 1972.

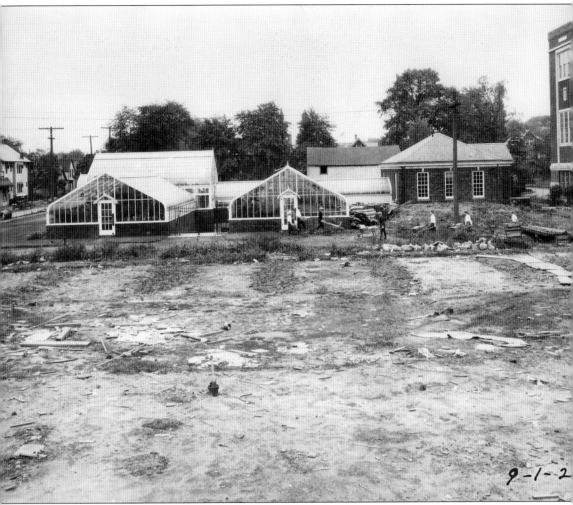

What would become a 1.66-acre track garden at West Technical High School was a vacant lot after the temporary classrooms were hauled away. West Technical was the home projects and garden science supply center. The school offered vocational horticultural instruction, Future Farmers of America and other horticultural clubs, adult programs, and in-service classes for garden supervisors and teachers. This view shows seven boys transporting garden boxes to the greenhouse in wheelbarrows. In front of the greenhouse is a stack of empty wooden boxes with handgrips. The boys are filling them with soil from the large dirt mound to the right. September 1, 1924, the date of this photograph, could be considered the very beginning of the West Technical tract garden.

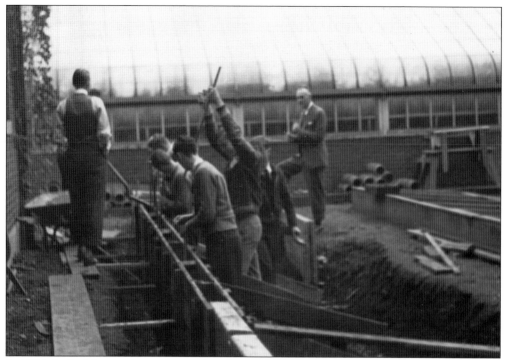

In 1937, the building trade and horticultural students framed and mixed cement for the compost boxes at West Technical. The teacher on the right is Albert Haqq. The students are putting rebar in the frames. Quite often the students would take on projects like this to get experience in their field.

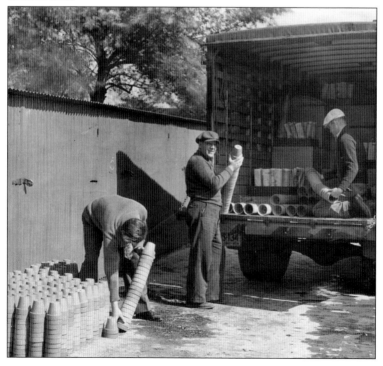

West Technical was the supply center for all the tract gardens in the system. By late winter the deliveries to the schools and garden centers began. Thousands of seed packets, live plants, tools, topsoil, fertilizer, and project supplies for the classroom were delivered. Trucks full of garden goodies were a much-anticipated event for the tract gardens. It meant spring had arrived and the planting season had begun.

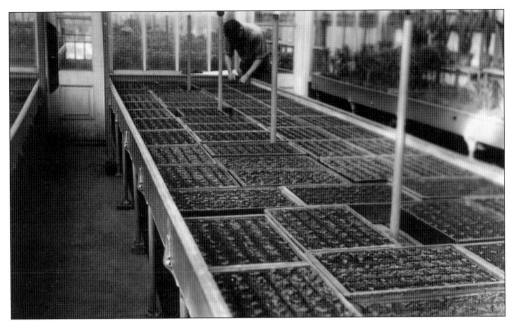

From the very beginning, West Technical was the supplier of starter plants for the rest of the system. The greenhouses had none of the modern systems. They could not "force" plants to grow, nor did they have modern watering and fertilizing systems. The students and the garden teachers did all the work at the greenhouses.

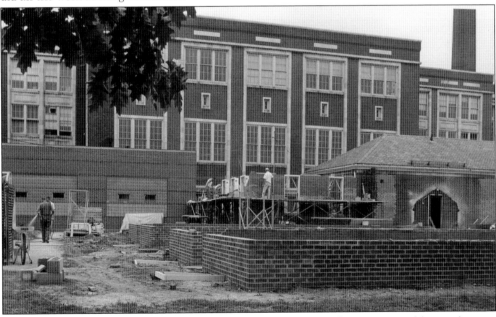

In 1966, there was a big push in the garden department to introduce vocational horticulture to all the high schools in the system. With the help of state funding, more than $350,000 was spent to improve facilities and equipment for the vocational horticulture program at West Technical High School greenhouse, Harvey Rice school garden tract, and the Collinwood High School-Memorial school garden tract and new greenhouses. The old West Technical greenhouses were demolished and new ones constructed.

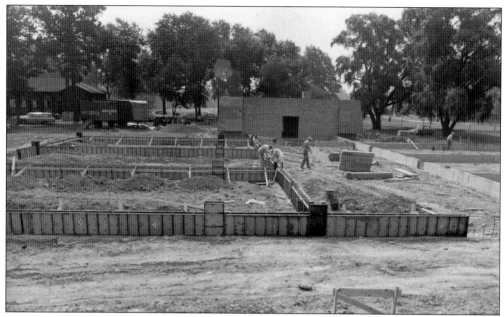

Superintendent Paul Briggs said the job would take five years and $2 million. He was referring to the building of Washington Park Horticultural Center, lauded to become a "living laboratory" for Cleveland's vocational agriculture program, the largest in Ohio. The workers are building the foundations for the center's greenhouses in this 1971 photograph.

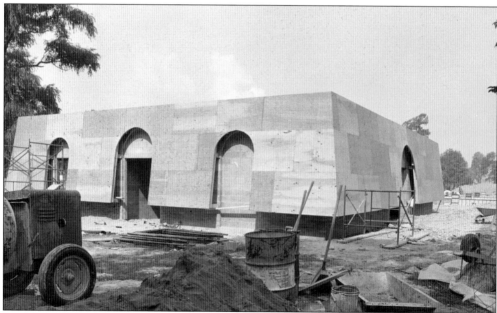

After many years of neglect, the area above Cleveland's famous steel mills was to be a multifaceted complex. The dilapidated picnic pavilion was made into a garden classroom. The greenhouse is a massive 80,000-square-foot affair attached to a shake-shingled service building. Grass, trees, and flowers planted by students and the neighbors enhanced the two new buildings. The service building had a large space for offices and work area.

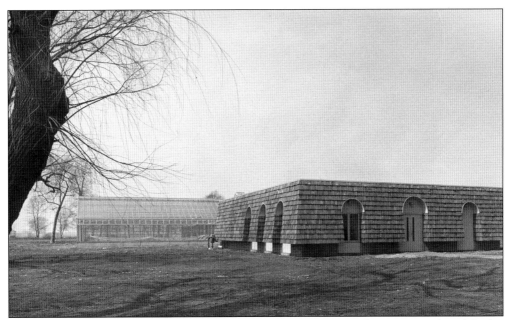

The finished product, bare and not so appealing, would become formal, experimental, and display gardens. A one-hole golf green was planned, and with the downsizing of many of the school properties, a full golf course was opened to the public on the Washington Park property 35 years later. The golf course property was given to the Cleveland Metroparks System and is now one of the First Tee youth program courses.

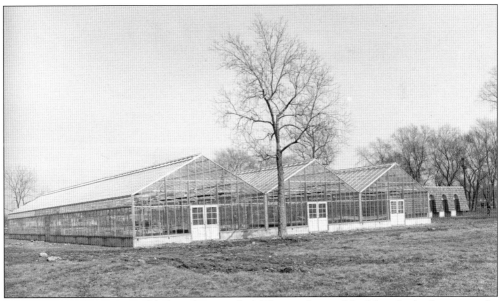

Two more buildings were added to the complex. The mechanical building had a huge area for storing the farm tractors, backhoes, and the park's small school bus. Small-engine repair classes were taught in the building's classroom. The second building was for small animal care. This building was very popular in the neighborhood, and residents loved to have their dogs groomed at "the park."

This is the interior view of the small-engine repair classroom and storage space for the larger garden equipment. The plywood area behind the man in the suit smoking a pipe is the tool room. To the left, behind the wall, is the classroom. This was open-house day in October 1971.

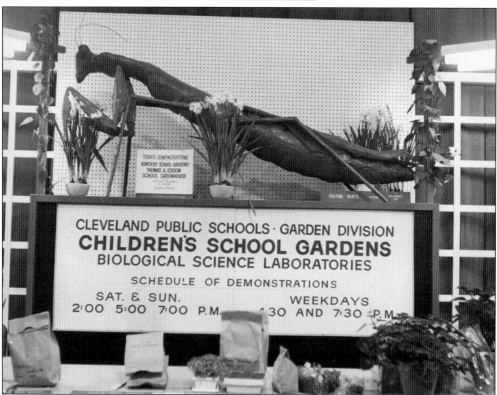

The garden centers all took turns showing off their gardening skills at the annual home and garden show. Demonstrations would be held at scheduled times. Only students who auditioned and were chosen were allowed to do a demonstration. The schools up for presentation the day this photograph was taken in March 1963 were Kentucky School Gardens and Thomas A. Edison school greenhouse. The small sign underneath the praying mantis reads, "Praying Mantis, Friend, Enlarged 20 times."

Two

HOME AND VICTORY GARDENS

During World Wars I and II, home gardens were called victory gardens. The transition from home garden to victory garden was easy for Clevelanders, who were virtually raised to garden at home because of their instruction in Cleveland Public Schools. Some 10,000 students from third through sixth grades had home gardens, not counting the hundreds of senior high students who gardened at home.

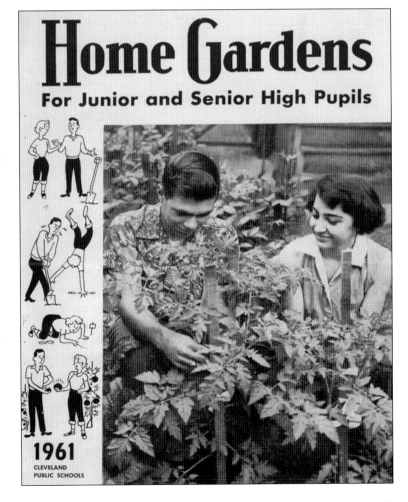

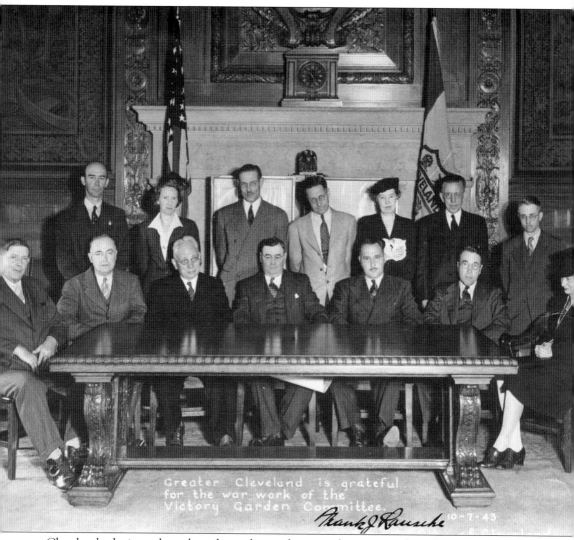

Greater Cleveland is grateful
for the war work of the
Victory Garden Committee.
Frank J Lausche 10-7-43

Cleveland ethnic enclaves lent themselves to home and victory gardens. For instance, one of the largest Slovak populations outside of Slovakia was in Cleveland. Slovaks were traditionally farmers, and this culture carried over to their adopted country. Tract gardens and home gardens were everywhere in Cleveland since the early part of the 1900s. The victory gardens helped lessen the burden of feeding a population at war, and more foodstuffs could be shipped around the world. Each county in the state had a victory garden committee designed to report to the federal government on the gardens' progress. Pictured from left to right in 1943 is the Cuyahoga County victory garden committee: (first row) George Nichols, Howard Ward, Dr. A. J. Culler, Robert P. Brydon, Herbert Meyer, Paul Young, and Helen Grant Wilson; (second row) Walter Pretzer, Dorothy Ellen Jones, A. L. Munson, Henry Pree, Mrs. Donald Gray, Floyd Bradley, and John T. Howard.

The war effort became everybody's business. Sugar, coffee, milk, cheese, meat, and canned goods were rationed, with families given ration books limiting the amount of food that could be bought. Millions of Americans, at the government's request, began planting gardens in their backyards and vacant lots. This poster was propaganda for the victory garden campaign. The garden tool became the citizen's weapon.

Victory garden campaigns began with assemblies in school and in places of business. Corporations launched their garden efforts, just like the school system. The flag, victory banners, and live flowers showed the patriotic spirit of the time. Awards were given, and letters of congratulations were sent to deserving gardeners from the National Victory Garden Institute in New York.

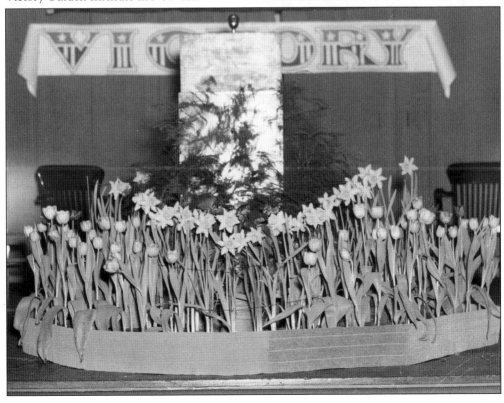

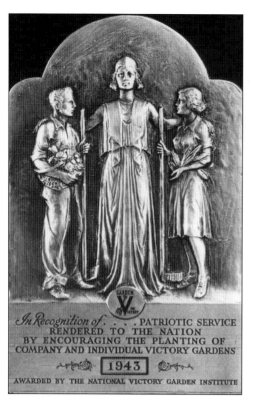

The National Victory Garden Institute Plaque was awarded to organizations that performed outstandingly in their victory garden programs. The plaque, the highest award presented by the institute, measures 10 inches by 16 inches and has a handsome bronze finish. Each year that a company met the standard of excellence, it was given an attachment bearing its name and year.

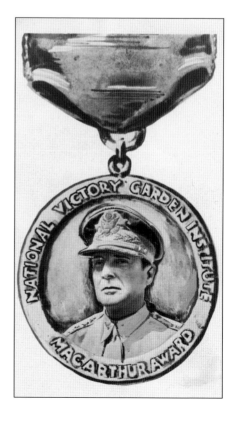

General MacArthur, one of the busiest war generals, was asked to endorse a medal for excellence in victory gardens and consented to have his picture placed on the medal. This medal, awarded in May 1945 by the Boy Scouts of America, is today a collector's item.

Cleveland Public Schools, Department of School Gardens

Victory Garden Enrollment Card

Name *Barefoot Beryl* Age *11* Grade *6 B*

Address *12813 Melgrove Ave* Tel. *Mi 2514*

School *Miles* Room No. *305* Date *3/19 '43*

Your signature above indicates that you wish to have a Victory Garden during the coming season. It is your patriotic duty to do the work necessary on this garden in the best manner possible and to obey all rules and regulations. You are to pay a fee of $ *40* to help cover the cost of seeds and plants, and this fee is not returnable after the work once starts.

PARENTS CONSENT: I am willing to have the above child carry on a garden project and will cooperate in its success. I understand that attendance twice weekly during the vacation period, for care of the garden, is a requirement. I also understand that continued violation of this or other requirements may result in loss of the garden.

Signed *H Barefoot*
Parent or Guardian

One of the most anticipated moments in a Cleveland child's life was when the science teacher asked, "Who wants a victory garden this year?" The children around the United States wanted to be a part of the war effort. The victory garden fee was 40¢ and victory garden enrollment cards would be issued. The students were reminded that it was their "patriotic duty to do the work necessary on this garden in the best manner possible."

Week	Calls			Notes and Comments		Attendance		Weekly Score	
	Tel.	Mail	Home						
1									
2				/	/				
3				/	/				
4					/				
5				/	3	2	Gold	Blue	
6				/	/	3	3	Gold	Gold
7				/	/	3		Gold	
8				/		3		Gold	
9				/	/	3	3	Gold	Gold
10				/	/		3		Gold
11				/	/	3	8	Gold	Gold
12						2		Blue	
13				ACHIEVEMENT RECORD					
14				Fl. Show	Veg. Show	Other Act.			
15									
16									
17									
18									

An achievement record was printed on the flip side of the enrollment card. The visiting garden teacher would record attendance and give points for attitude and work done. These cards were used in the tract gardens as well as home gardens. A colored-dot sticker was used to measure achievement and would be placed on a certificate. Gold was for perfect attendance; other colors were used for actual garden work.

The reality of life during the war was that the garden teacher had to come up with lessons that kept the children busy and their minds off the conflict. One of the favorite exercises was the identification of trees by their leaves, and if it was winter, by their bare branch structure. These youngsters were tract gardeners at Miles Standish Elementary.

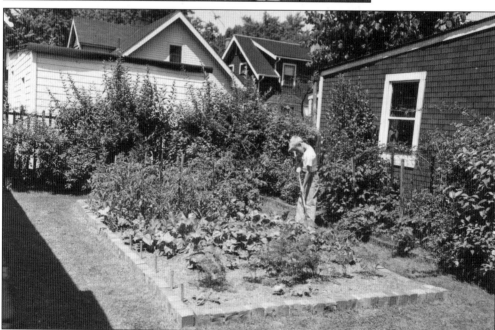

Corlett Elementary School student Alan Mastny is shown in a typical home garden at his 13901 Svec Avenue residence. The garden is placed next to the garage and neatly surrounded by a brick border. Some gardeners would purchase raw cow manure as fertilizer for their gardens, which did not always sit well with the neighbors.

The home garden concept was established because many students lived too far from a tract garden could duplicate a tract garden right in their backyard. Schools furnished all the supplies and seeds. George Rivers is proud of his home garden at 7024 Wade Park in this 1950s photograph.

Vacant lots were prized locations for home gardeners. Ironically this is how the garden project started—the beautification of vacant lots. These gardeners show how different sizes of gardens were acceptable. Early in March of each year, a home garden promotional program was conducted in each school. Recruitment began soon after through science classes.

The boys are proudly showing their mother their garden. This photograph was used as a lead story in the *Clation-Ledger* of Jackson, Mississippi. The headline of the story read, "Cleveland, Ohio, School Gardens are Big Project." The article went on to state, "In 1958, students enrolled in the home garden projects from 119 elementary schools, 25 junior high schools, and 11 high schools, with bulk of the enrollment coming for the third through eighth grades."

Neighbors Merl Heisler (left) and Mary Sievers pose in front of their East 126th Street home gardens in this 1938 photograph. Paul Young, supervisor of gardens, wrote in his *School Gardengram* magazine, "The real purpose of gardening as a school activity is education of boys and girls."

Diane James of 2073 West Eighty-First Street gives her mother some fresh-cut flowers from her home garden. Not all the children chose vegetable gardens for their homes. Flower gardens were a favorite of many children. Generally there were three types of garden activities for Cleveland pupils: the first, and most popular, was the school tract garden; second came the short-time garden project, usually done in the classroom; third was the home garden.

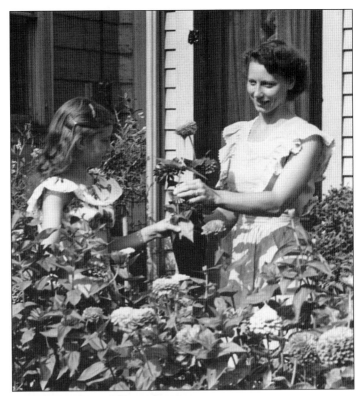

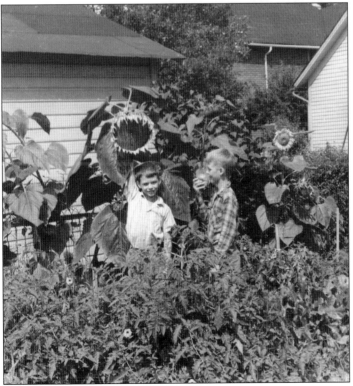

Sunflowers were a favorite in the home garden. Gary Polinkes holds up the head of the sunflower, while his brother Philip gets ready to take a bite out of a fresh-picked tomato. The enrollment fee for a vegetable garden in 1961 was 75¢, which provided the students with 10 seed packets, three tomato plants, two pepper plants, onion sets, fertilizer, and Rotenone pesticide to start their garden.

59

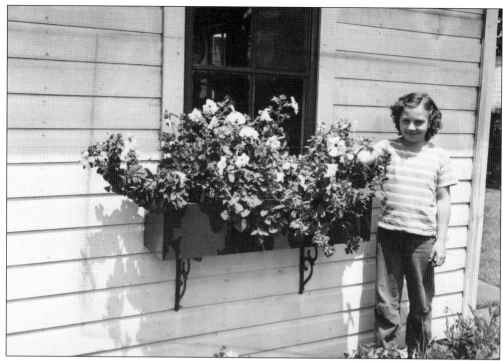

Home gardens could sometimes be just a flower box by an outside window. Dorothy Alik of 9605 St. Catherine Avenue is proud of her plant box. Dorothy's home school was Woodland Hills Elementary School in Southeast Cleveland. Woodland Hills Park was close to the school, and in the early part of the 20th century Woodland Hills (Luke Easter Park) was the site of the first Cleveland airport.

George Meyers (left), Eugene Novak (center), and Frank Novak did not need large prizes or free gardens to pique their interest in gardening. These eager gardeners, pictured in 1938, were from Tod School located off Union Avenue on 65th Street.

This unidentified little girl looks very pleased with her garden. The home garden program was considered the gateway to a full tract garden program for school districts. It was easy to manage and inexpensive to run. In the beginning of the Cleveland program, teacher interest was the only prerequisite to form a home garden program.

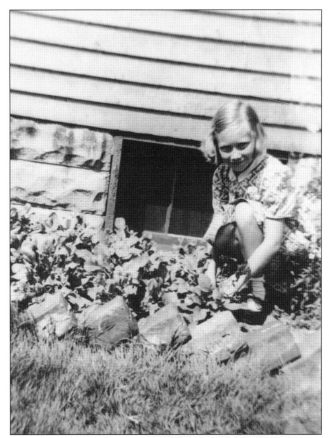

May Habart's (second from the right) home garden is shown after her teacher had evaluated it on her second visit in 1938. Alice M. Bertoli (back right) was the summer garden instructor from May's Tod Elementary School.

There is nothing like eating a fresh tomato out of the garden. Flower home gardens could be bought for an enrollment fee of 35¢. For that fee, the students would receive six packs of flower seeds and fertilizer. For an extra 25¢, the pupils could have their very own plastic squeeze duster.

In this 1922 photograph, a man observes his granddaughter stringing a row to start her home garden, with her planting plan on the ground. From the very beginning of the garden program in Cleveland, the instructors observed how home gardening brought families together. It was not until the gardens closed that the parents realized how important they were. The contact with the horticulture teacher, twice a summer, was possibly the only contact that some parents had with their child's school.

Twins Ray (left) and Robert Platt lived on 3614 Germaine Avenue in the southwest of Cleveland. Home gardening gave the kids the freedom of gardening at their leisure. The boys are inspecting their freshly picked Swiss chard, one of the favorite vegetables in all the gardens.

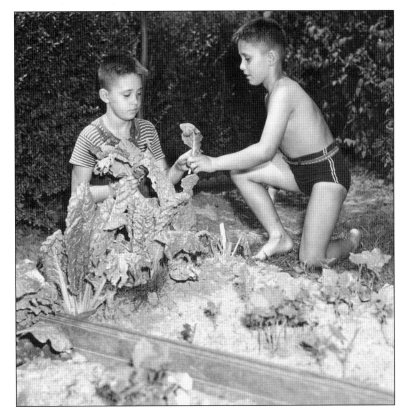

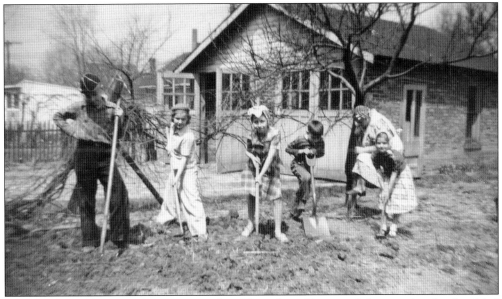

The family that hoes together stays together. These five siblings and their mother (on far right) know the importance of working together. The board offered families a plan-it-yourself garden project. The plan was limited to experienced pupils who had received three or more certificates or a silver pin award in previous years. The enrollment fee was $1 for 12 packets of seeds, one grow-kit, 24 peat pots, two trays (for starting seeds indoors), fertilizer, and Rotenone dust.

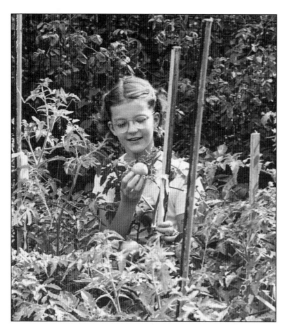

This young girl is inspecting the fruit of her labor. Not surprisingly, the preference for the type of garden in Cleveland ran two to one in favor of vegetable gardens. For the most part, second-generation immigrants did the gardening, with food crops grown in favor of those grown for their cosmetic appeal. The rules forbade the parents from helping in the garden, but the hand of the father and mother was evident in the selection of particular vegetables.

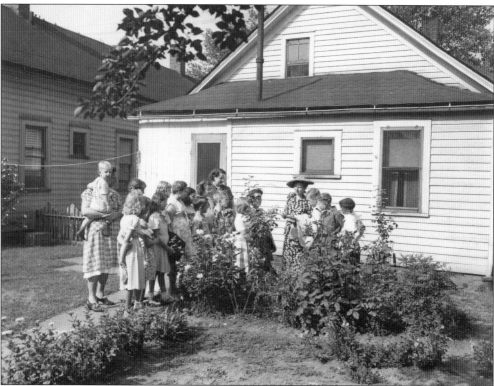

The visiting teacher arriving to evaluate the home garden was always an occasion for the neighbors and the kids to come out. This teacher, in her wide-brimmed hat, captivates the attention of children and mothers. Visiting teachers could be the teacher who enrolled the pupil, the director of the program or assistants, or a PTA member. Quite often garden club members volunteered for the work.

In this 1963 photograph, Ken Riebar is showing off his freshly harvested beet. Ken attended West Technical High School. The visiting garden teacher was expected to make 25 visits a day. The evaluator was paid $9 a day, making the cost per visit 36¢. The purpose of the visits was more to help student gardeners and keep them on task rather than evaluate their work.

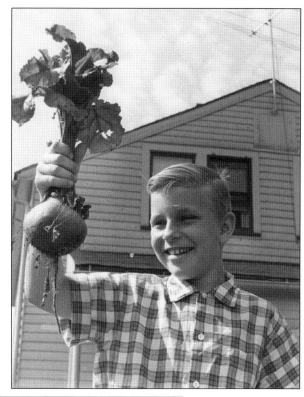

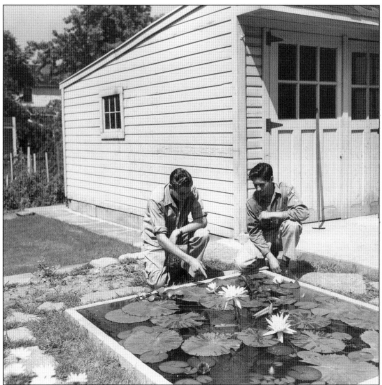

High school students were encouraged to plant experimental gardens. These gardens could be as different as the atomic garden (seeds were treated with special chemicals) or as unconventional as a lily pond in an urban backyard. These senior high students had to ask permission to plant this pond and have it count as a home garden. Cleveland at one time was considered the greenhouse capital of the nation.

In this July 1952 photograph, Patrick Henry School student Andrea Perry ties her tomato plants at her home at 12708 Woodside Avenue. The horticultural department would issue certificates to pupils who successfully finished their garden project. This usually meant that the students entered their vegetables in a garden exhibit. The Garden Center of Greater Cleveland also gave special awards.

The *Cleveland Plain Dealer*, the sponsor of the Green Thumb Club, gave each student gardener prized free tickets to a Cleveland Indians baseball game and the Cuyahoga County Fair. This photograph is typical of an inner-city garden in the middle of the smoke-stacked industrial district of Cleveland.

Three

STUDENT GARDENERS

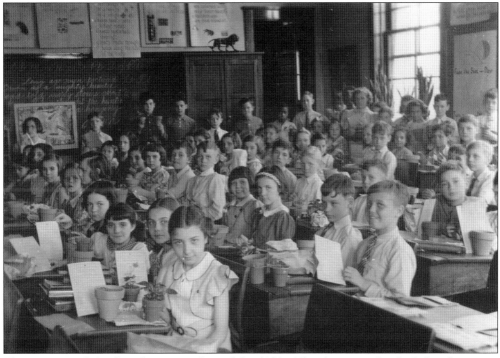

This is a typical third-grade science class of the 1920s. They have just finished their lesson on gardening and are showing their lesson worksheet and the results—the potted plants. As Dr. Peter Wotowiec wrote in *The Agricultural Education Magazine* in the 1970s, "Gardening is a very relevant way of teaching youngsters how and where they fit into the environment."

There was a great deal of preparation in the classroom before a hoe ever touched the ground. The student gardeners read their garden bulletins weekly to see what was expected of them in the garden. Having a tract garden was a privilege. The minimum requirement was that the students care for their gardens at least twice a week during the summer.

The garden centers throughout Cleveland would receive thousands of pounds of seeds for all the activities slated for the classroom, as well as for the tract gardens and home garden projects. At each center, the student workers would weigh the seeds, put them into packets, and distribute them to their "feeder schools." A drawing of a garden plot was on each envelope. The science teacher would then distribute them to the classes.

These four youngsters from East Clark School look happy after receiving their garden seeds in May 1944. By the middle of the 20th century, over 100,000 seed packs per year were distributed to public and private school pupils in Cleveland. The amount of seeds and bulbs distributed grew every year. In 1969, some 92,820 children received seed packets for the spring units and 69,020 for the fall units.

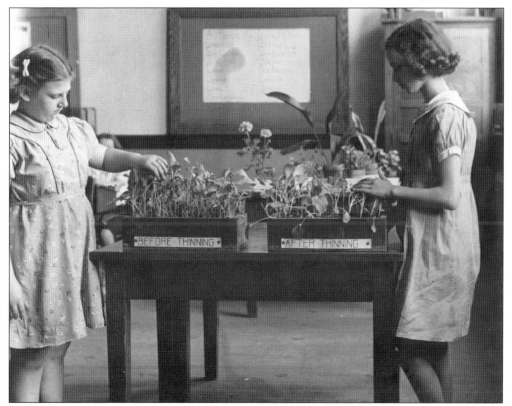

The lessons taught in science class were practical. The students would work on garden projects to replicate what happens in the "real" garden. Basic garden techniques such as thinning plants and the reason for doing so were demonstrated.

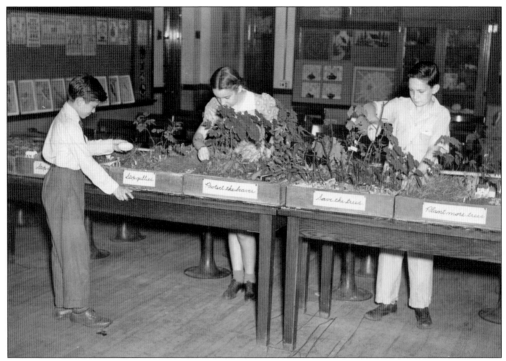

The science fairs (not to be confused with garden fairs) had a close relationship with the plant science classes. This science class in the late 1930s is making a science project showing the importance of proper soil management. The labels on the examples read, "Stop gullies, protect the beaver, save the trees, and plant more trees."

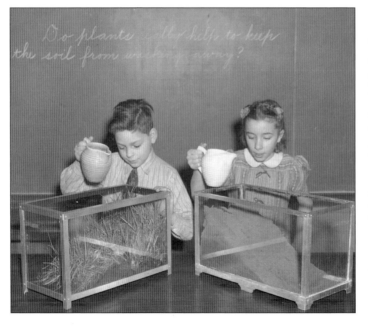

Teachers knew for students, doing something with their hands was often better than reading about it. The question on the blackboard reads, "Do plants really help to keep the soil from washing away?" The eager students are going to prove the correct answer. The teacher hoped the lesson would carry over to the students' home gardens. Often times, the science teacher would be their home garden evaluator.

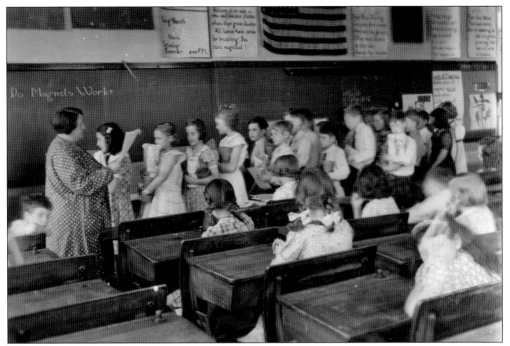

Here is a science class in perfect order. The teacher is checking the results of a botany class. The poster above the blackboard next to the flag reads in part, "All leaves have pores for breathing. See them magnified."

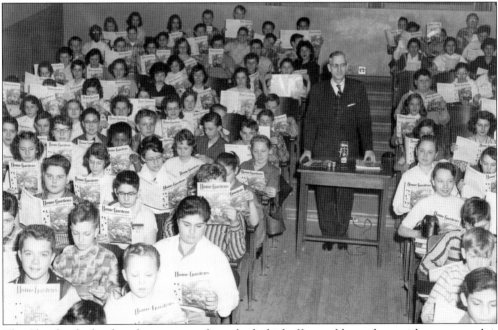

The Cleveland school garden program always had a kickoff assembly run by a guidance counselor. In this March 1958 photograph, these seventh graders are reading their home garden brochure while awaiting a slide show of highlights from the previous year's garden projects. The sign-up for the tract gardens or home gardens would happen immediately after the presentation.

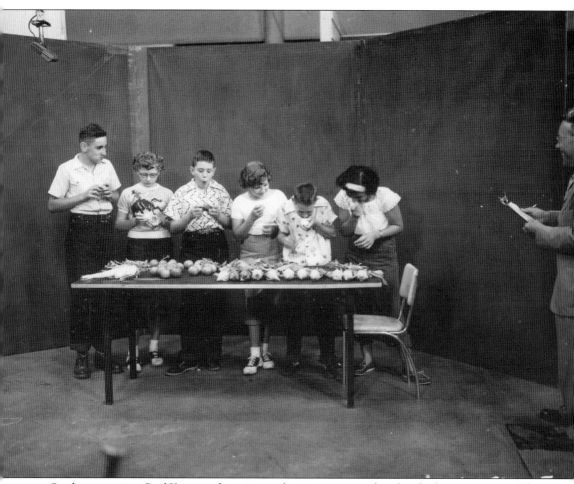

Garden supervisor Paul Young is directing a television program for a local television station. This is perhaps the only television promotion showing the students of the Cleveland school gardens. The students are enjoying a bite of the fruits of their labor. The television work was short-lived, but radio was used to promote the garden project from the very beginning of broadcasting. In 1969, some 1,080 classes listened to 43 lessons broadcasted on WBOE, the board's radio station.

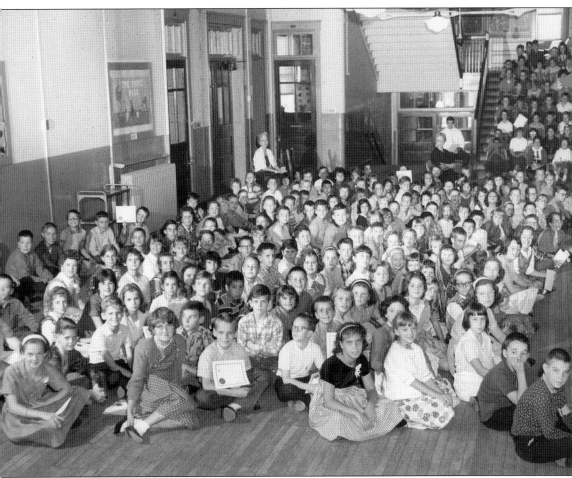

Students are posing in this Gilbert Elementary School photograph taken at the time of their garden assembly. Children from grades 4 through 12 were offered eight different home garden projects. Garden projects were voluntary, and the enrollment fee ranged from 60¢ to $2. If a child's family could not afford the fee, teachers usually paid for the garden out of their own personal funds. The fees were token and never paid for the total cost of the supplies. Part of the closing of the gardens, years later, was due to the board of education no longer underwriting the costs. The number of children enrolled for these projects was 160,000 in 1969. This number does not include the 19,804 home garden plots supervised by the horticulture department.

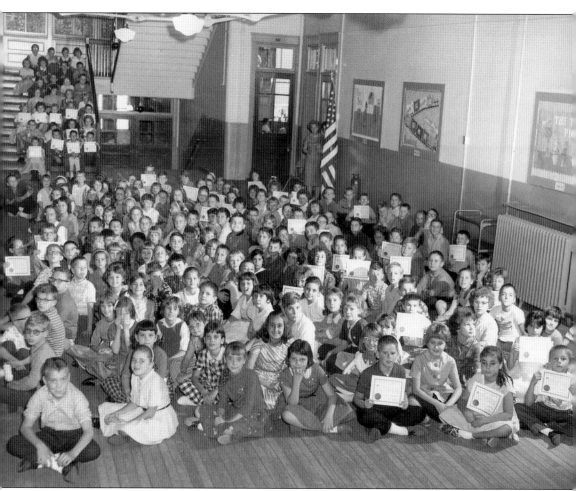

Students took part in the gardening project by the thousands, as evidenced here in this all-school photograph opportunity. These photograph opportunities occurred immediately after the yearly garden awards assembly. The children are holding their gardening certificates. The certificates were color coded according to how many years they spent in the program. The early gardening program started in the 3rd grade (later all grades were included) and continued to the 12th. The highest honor a gardener could earn was the Agricola award.

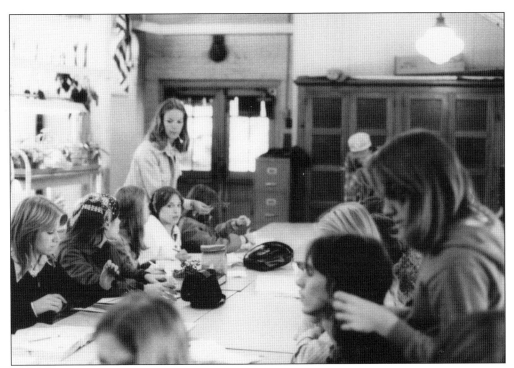

Joanne Scudder conducts a floral class in the garden classroom at Benjamin Franklin School. This classroom was in use for over 60 years. When the garden program ended in the late 1970s, the building was closed for many years. In the 1990s, the neighborhood garden organization reopened the building and is now conducting classes there again. Scudder went on to become chairwoman of Washington Park Horticultural Center.

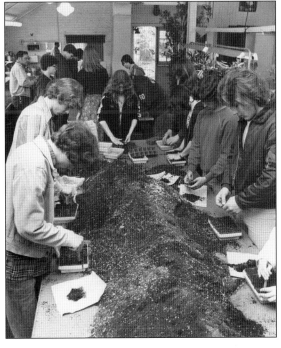

This c. 1975 photograph shows the gardeners preparing seed pods for the greenhouse at Benjamin Franklin. The tract garden at Franklin produced close to $50,000 worth of produce, but education was the real value of the program. Gardening was a field laboratory for pupil development in the areas of environmental sciences, practical mathematics, social interaction, and career exploration.

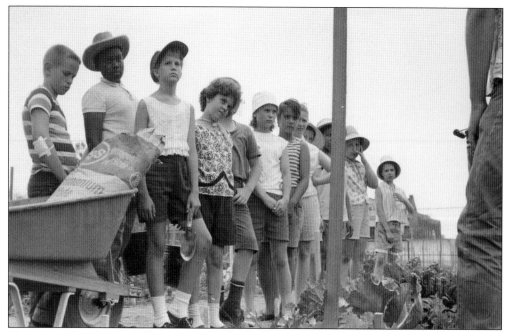

This group of students at Miles tract garden learns how to fertilize gardens. Fertilizing was just one of many garden chores. After each lesson, they would return to their garden and apply what had been learned. Teachers of primary grades and their assistants would stake and line the garden for the students. There were three sections of 10 plots each, so each staked line took care of 30 gardens.

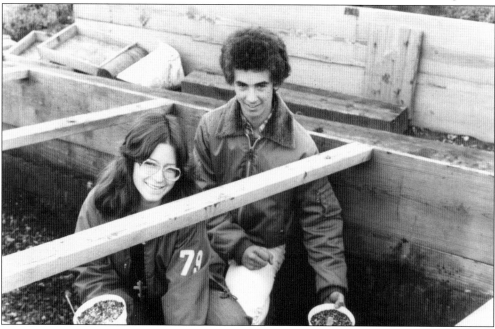

Setting out potted plants into cold frames was an early spring chore for Noreen Milain and Don Arthen of John Marshal High School. These seniors were gardeners at R. G. Jones tract garden in 1977–1978. The seniors were probably unaware that this was the last season of the school-wide garden program.

Karen Simpson and Bernard Czeka are removing the covers of the cold frames in the spring of 1977 at R. G. Jones School. The following school year, an impassioned letter was sent to the Ohio governor to help keep the garden project, stating, "This past August was the 13th and last Children's Garden Fare [sic]. It was the last because the Cleveland Board of Education has eliminated the program entirely." The board prevailed.

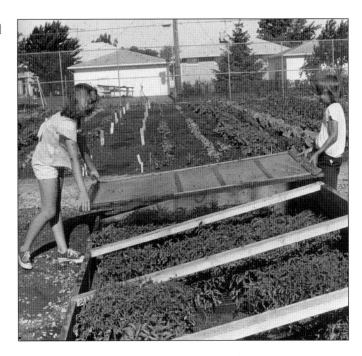

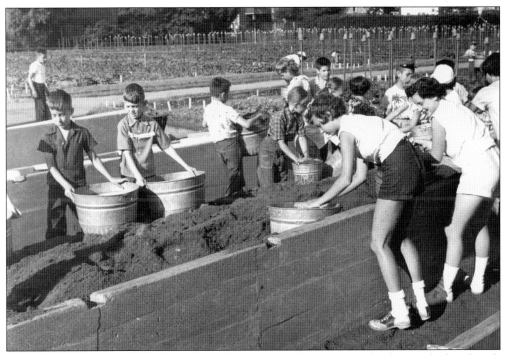

The gardeners at Harvey Rice are shoveling "black gold" humus into buckets with their hands to prepare flower beds along the garden paths and to mound squash and other vine plants. Washington Park Horticultural Center was a depository of composting waste from cities around Cleveland. Kenneth Parker was in charge of the pile of compost. The humus was distributed to all the tract gardens.

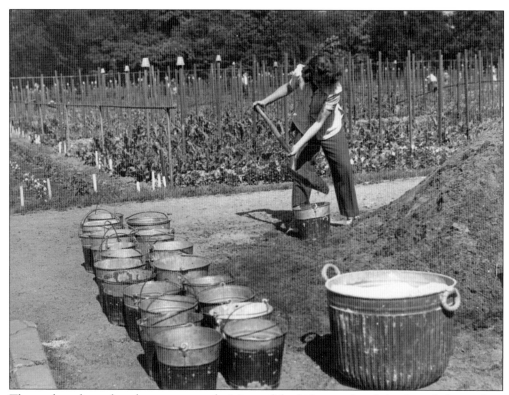

The students knew how humus was made. Many of the kids transferred this knowledge to their home gardens. Besides the surrounding cities, Washington Park offered golf courses, park districts, and cemeteries a way to dispose of their waste. The kids in the tract gardens learned quickly how important balanced soil was to their plant growth.

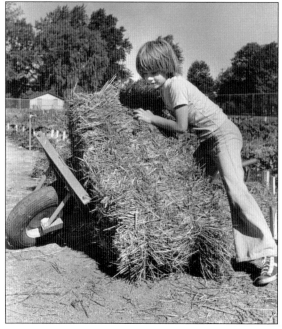

In this July 1, 1977, photograph, gardener Ann-Marie Flak is wrestling with a bale of straw. During the summer classes, the students were expected to farm their plots. The straw was used to shore up the tomato and pepper plants. The student gardeners would work an hour and a half in the morning and an hour in the afternoon. The week would be broken up into two-day sessions.

Rototillers did not come into use until much later. West Technical and Washington Park Tract Centers held small-engine repair classes. Washington Park still has engine repair classes taught by Eric Passow. The park serviced all the garden machinery for the board of education. The board was self-insured and repairing its own machinery kept costs down. The picture is obviously a staged photograph opportunity. The two unidentified people, dressed handsomely, look like they had just come from church.

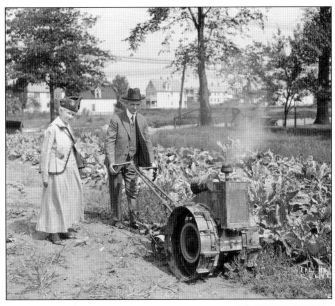

These Garfield School tract garden students are looking over a new garden tractor grass cutter. The boys would be asked to cut the grass around the school. Often the test drive was a good excuse to "kill" a couple hours of class time. Notice the reel-type grass-cutter attachments on this tractor.

East Technical High School on 55th Street was the counterpart of West Technical on the east side of Cleveland. The East Technical students would go to outlying farms close to Cleveland and bring back clover chaff to form the vegetable beds. In the 1910s and 1920s, the outlying farms could be as close as 10 minutes away by truck.

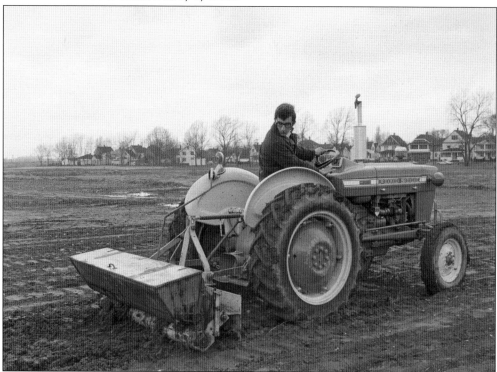

In the beginning, the students would till the ground by hand. With the advent of machinery repair in the vocational horticulture curriculum, all the large gardens were plowed with large tractors. The students would also spread fertilizer with the heavy tractors. It was a happening every time the tractor showed up to cultivate the tracts. This vocational education student is spreading manure at Washington Park Horticulture Center.

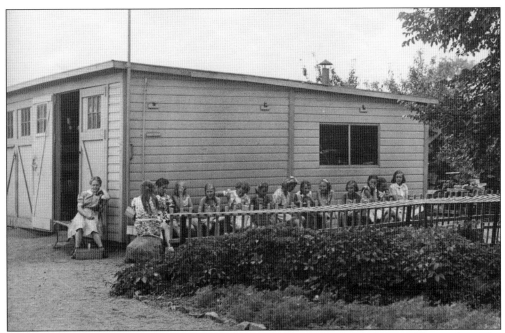

The students are waiting for their science teacher to open the Benjamin Franklin garden. The kids were graded on whether they had a true interest in gardening, were well informed about procedures, and if they actually did the work. A garden grade card was kept on each student and was a part of the overall science grade.

The assignments for garden chores were posted each day on the garden shed. The students are checking the "to do" list. It looks like the gardeners with baskets in hand are about to harvest on this day. There were two harvests in each tract garden: one in spring before summer vacation, usually of radishes and leaf lettuce; and the late harvest in the fall.

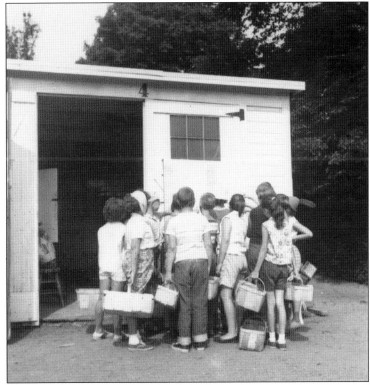

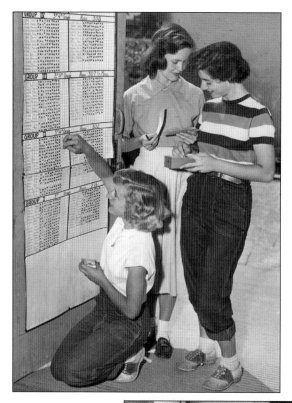

The star chart was a way of grading the pupils throughout the growing season. Students were graded on attitude and their ability to get along with other gardeners. The groupings were made according to grade and schools attended. Each garden visit was scored and recorded by a color-coded star. The girls are Irene Molinar of Shaker Heights (left) and Joan Torok (center) and Marion Thomas of John Adams High School.

The gardeners were evaluated on how well they followed the plan, weeded and cultivated, thinned the plants, planted late crops, the type of crops used, how well their plants thrived, and pest control. The evaluation worked the same way for the home gardens. These kids are checking the Rolodex to find their grades.

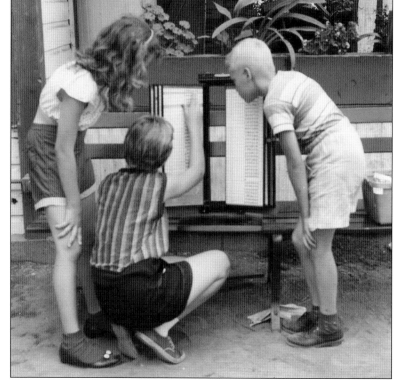

After they checked their assignments for the day, it was off to the garden. The garden shed was set up so that every student had preassigned numbered tools that they were responsible for the whole season. The tools and watering cans were all color coded by tract garden. The colors stood out so the superintendent of the garden could easily tell whether a particular tool belonged to his garden. The colors in the garden made for a striking image.

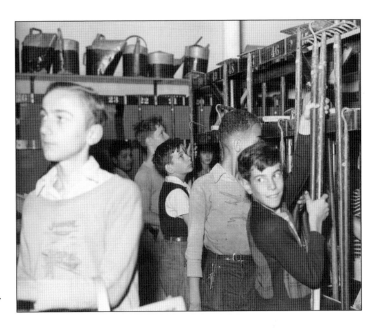

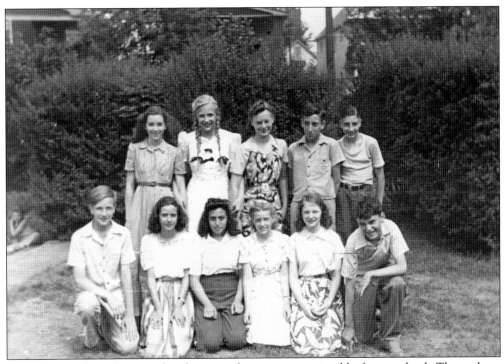

Pictures were taken of groups of gardeners, in this case seniors, just like for a yearbook. The students were encouraged to dress well. The superintendent of the tract garden would make scrapbooks of all the classes from various feeder schools. Unfortunately the students in the photographs were not identified a great deal of the time. This grouping is from the 1940s.

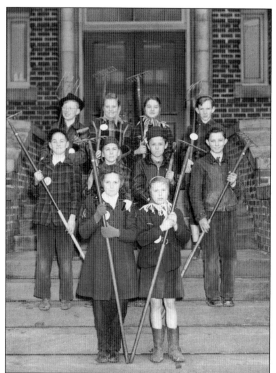

With tools in hand, these Garden Cadets are ready to start work. The *Cleveland News* afternoon daily paper sponsored the Garden Cadets. Not to be outdone by the *Cleveland Plain Dealer* and its Green Thumb Club, the cadets earned many garden awards. The *Cleveland News* was sold to the *Cleveland Press* in the early 1960s.

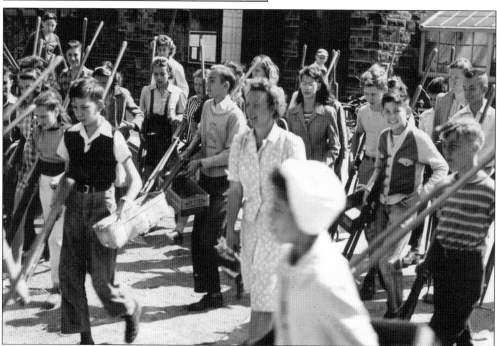

School gardening was a happy time for these students walking with their teacher out to the tract garden behind their school. Notice that the students are holding the garden tools with their sharp edges facing the ground. The first lesson in gardening is safety. On the doors on the garden building in the background are the student assignments and grades.

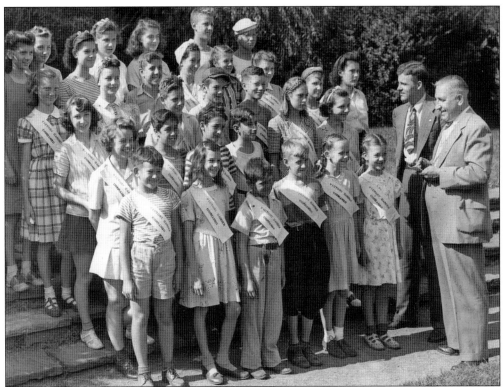

Before going out to the garden, the Harvey Rice PTA victory garden patrol receives instructions from Capt. Arthur Roth and Patrolman George Pollick in August 1943. Arthur Roth was the captain of the Cleveland Police Department's juvenile unit. Besides helping the Cleveland garden program, he formed the Cleveland Midget Hockey League for young hockey players. Captain Roth Elementary School was his namesake.

Jim Brucato (left), Les Beamish, and Anne Lewis are planting tomato and pepper plants at the Cleveland Press garden. The *Cleveland Press* was always a very community-aware newspaper. The garden was right in front of the Press Building. Les Beamish was a garden teacher and photographer.

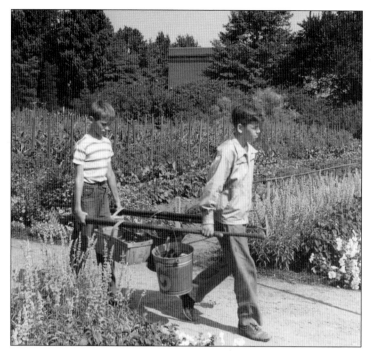

The boys are carrying their tools the easy way. They were taught to carry the buckets and baskets in tandem. The work was made easy with help from a friend. The tract is Benjamin Franklin, which has had a long history of gardening that exists even today. Many a youngster was trained in horticulture and later became employees of the Cleveland Board of Education. Dave Stephans, William Zmich, and Joe Brosch are just a few people who worked in the gardens as adult teachers.

Fifth-grade student Amy Mudra assists kindergartners Larry Turley (right) and Tony Bonnacci planting onion sets, which were the easiest of the vegetables to plant. The idea of students assisting students has a long history in the gardens. Often little brothers and sisters would follow the footsteps of their siblings. Family gardens of students were quite common throughout the system.

In Miles tract, 12-year-old Gayle Scaletta of 137 South Parkway Drive is helping 6-year-old Ann Marie Rovinell of 12004 East Boulevard tamp down radish seeds. Radishes were always the first seeds to be planted, and they came up first as well. After the harvest of radishes, the line was replanted with lettuce or beans for a second crop.

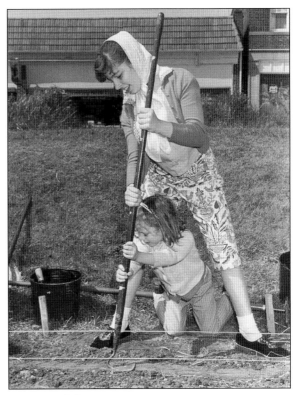

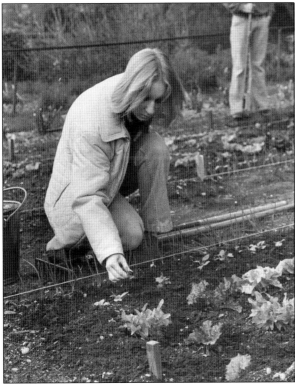

Vocational educational student Eva Kubiak demonstrates the proper way of thinning the crop in this 1970s photograph. Because the individual garden space was so precious, the emphasis was always on maximizing production per square foot. The Cleveland Vocational Education Program became very popular in the late 1960s and 1970s with the advent of Washington Park Horticultural Center in Newburgh Heights.

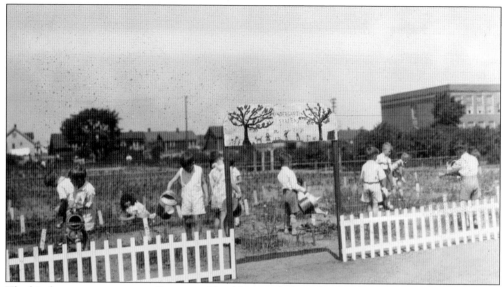

The kindergarten program at Benjamin Franklin was believed to be the first program for five year olds in the nation. The program ran from early spring to the end of school. The vegetables that were planted were onion sets, radishes, and lettuce. By 1971, some 1,850 children participated in the children's fair sponsored by The Garden Center of Greater Cleveland.

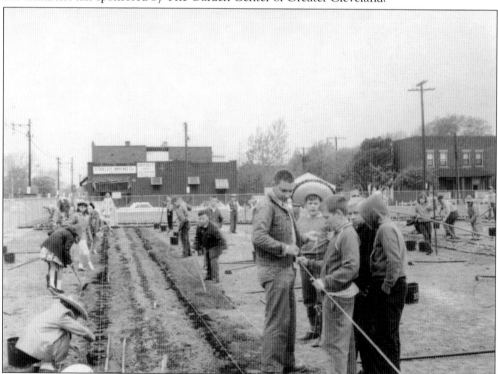

These Miles School students are striking a line for the rows of vegetable seeds in this late-1960s photograph. Horticulture teacher Nick Paserk directs the students. The kids on the left appear to be planting bean seeds. The two rows in the middle of the lines are already planted and tamped. This explosion of garden activity probably happened during science class.

Kim Reid (standing), eight-year-old Stephanie Rogers (left), and nine-year-old Reba Rogers are weeding and cultivating in their Henry Longfellow Tract Garden. Longfellow and Memorial gardens were paired under one garden superintendent. This was the standard practice in later garden management. The students are weeding and cultivating their plots.

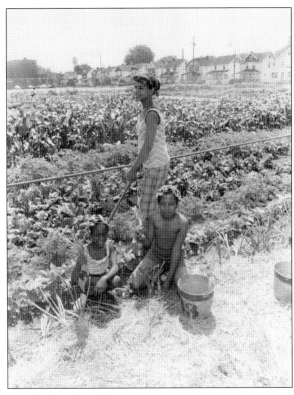

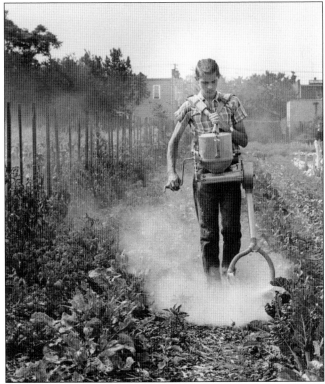

Long before Rachel Carson's *Silent Spring* was published in 1962 linking DDT and other pesticides with cancer, the student assistants at the tracts did the dusting for harmful insects. Occupational Safety and Health Administration officials would have had a fit to witness this gardener dusting plants without gloves, protective clothing, and a face mask.

Chris Yanik, age nine, and his two-year-old brother, Tim, of 2769 West 138th Street, are harvesting broccoli. Chris is from Garfield School on the west side of Cleveland. Pictures such as this were used extensively to "sell" the garden program to the parents. The smiles on the faces of the kids say it all.

Vegetables in his left hand and a sack, pail, and rake in his right hand, 10-year-old Mark Kundtz is ready to go home and show off his bounty. Although Mark was gardening at Douglas MacArthur tract on this July day in 1978, he was not a student at MacArthur, instead attending St. Patrick's Elementary School. The garden rule was if a child could walk to the garden, he was able to have a garden. Attendance at the tract garden school was not mandatory.

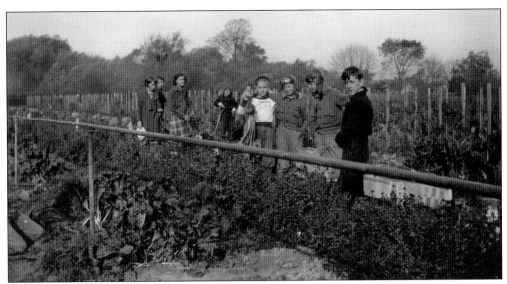

This early-1920s photograph shows a boy harvesting a beet from his Harvey Rice Garden. The girls on the left are admiring the boys in their bomber jackets and hats. The boys have their arms around each other in a sign of affection rarely seen today. The boys' style in clothing is a direct result of World War I and the flying craze that hit the country right after the war. The exploits of the flying aces in the war were fresh in their minds.

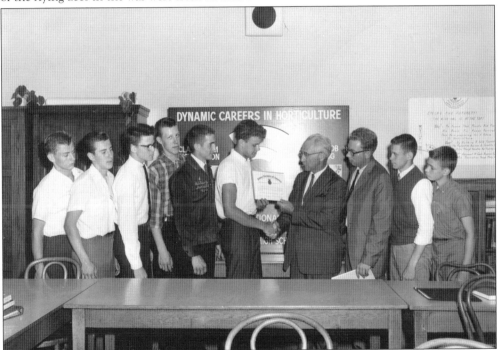

Student Bob Walker receives a Future Farmers of America (FFA) charter on May 31, 1962. The West Technical High School is the first Cleveland school to be a member of the FFA. The FFA is a national organization whose purpose is to teach better farming methods. West Technical's first FFA officers (not in any order) were Bob Walker (president), Bob Bruder (vice president), Chuck French (treasurer), Don Gordon (sentinel), Don Engel (reporter), and Den Maki (student advisor).

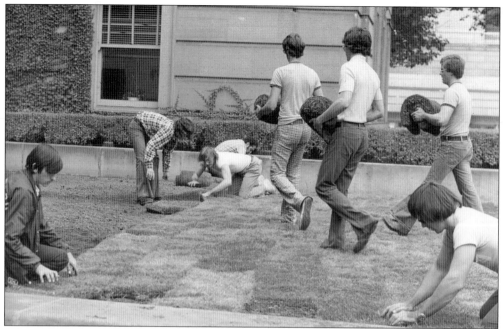

Often students from the different horticulture centers were called to the Cleveland Board of Education Headquarters on East Sixth Street in downtown Cleveland to do garden work. The gardeners are laying sod around headquarters on a warm October day in 1976. The students are doing this work right under the nose of the superintendent.

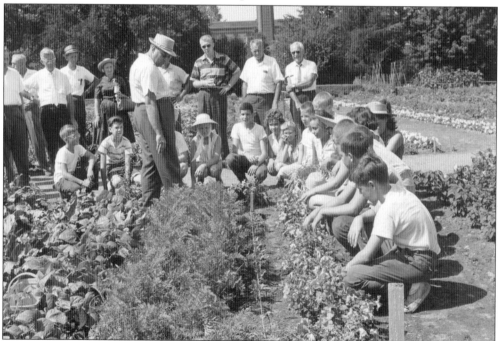

Garden superintendents would often have their meetings at the tract gardens. This July 18, 1963, photograph shows the garden supervisors and guests watching a class from Benjamin Franklin. The lesson that day was how and why replanting crops expands the garden without adding space.

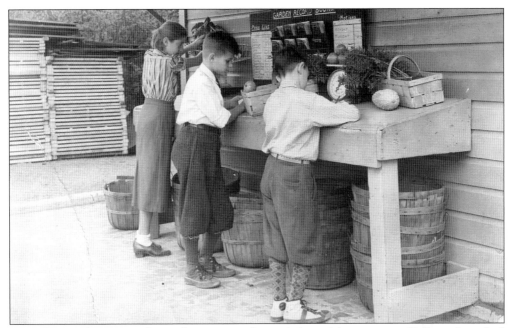

From the very beginning the garden program demanded careful accounting. Each gardener had responsibility to record daily activities in a garden record book. This was especially important at the harvest. The monetary equivalents were calculated to show the dollar amount each garden produced. Each tract garden had scales and lists to do the calculations.

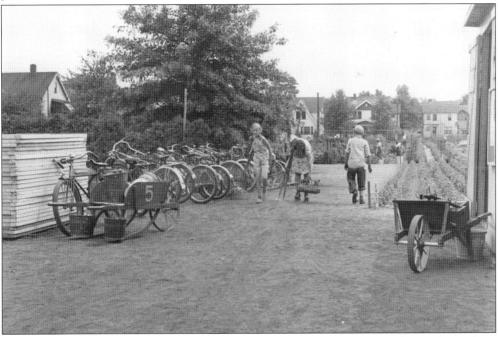

Benjamin Franklin was famous for its bicycle brigade of pupils riding their bikes to the gardens. At harvest time, the kids would ride around the garden with their baskets full of produce. The bikes were not the only wheels at the garden; the girl in the middle carrying the hoes and basket is on roller skates.

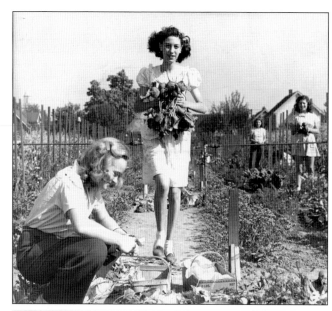

This early-1950s photograph recorded the beet harvest at Harvey Rice tract garden. The young lady in the foreground is "cleaning" the crops. Beets were a favorite in all the neighborhoods because they were canned and enjoyed year-round. Canning was not considered a hobby in the early years of the garden but was rather a way of life. Produce could be bought at the grocery store, but nothing beat the fresh tract garden products.

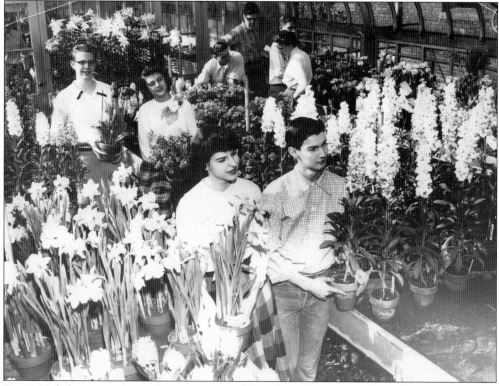

Bernie Nobel wrote in the student newspaper, "More than 100 West Technical High horticulture students put on their own flower show yesterday, 'green thumb' students included Mary Ann Melda and Jim Hlavaty (front couple) and Roy Kreuzer and Beverly Miller (back couple). West Technical Blossoms out by Rusty Brown. Blossoms of hundreds of spring plants transformed West Technical High's greenhouse into a pageant of color yesterday. The occasion was the 29th annual flower show put on by horticultural students."

Margaret Hoehn of 3001 East 130th Street is weighing her tomatoes from her Harvey Rice garden. In the early 1970s, there was pressure to reduce expenditures across the whole garden department. One plan was to grow all the plants needed for all the horticultural activities.

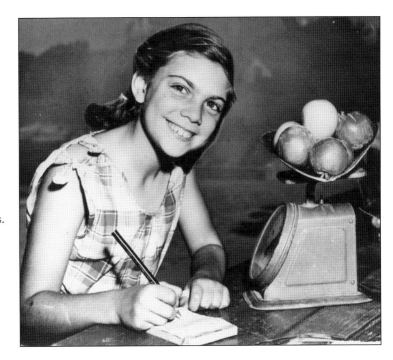

Carrie French from Tod School shows off her sunflower in this 1976 photograph. Dr. Wotowiec stated in 1973 that in order to keep the budget down, the gardens produced all the flowers grown for the gardening awards program "that resulted in an annual savings of $1,500. This effort, when fully realized in another year, will save over $6,000."

95

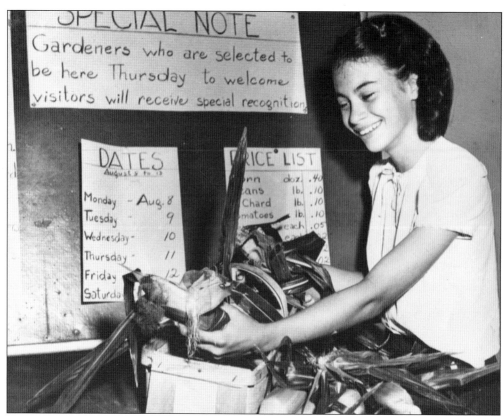

Shirley Beck of 11224 Lardet Avenue gardened at Harvey Rice tract garden. Her walk to the garden probably took half an hour. The Cleveland tract garden program actually grew students, enriching their character, health, and mind. There is something special about growing one's own food. What could be more delightful than a basket of freshly picked corn?

These tract gardeners at Harvey Rice gardens are weighing their harvest of Swiss chard. Each year the total dollar value of all gardens was reported to the superintendent of schools. Towards the end of the program in the 1970s, the harvest produced upwards of $1 million of value. In each stage of producing a productive garden, from the plowing to the harvest, the students experienced the life cycle of nature.

Science lessons at school included the study of insects. The tract garden was a great laboratory. Students would go out to the garden and catch bees or dig for larvae. One of the selling points to keep the gardens open when the threat of closing was eminent was the connection between the science class and the tracts. A more salient argument was that the board of education was reimbursed 100 percent for each student from the State of Ohio. The total reimbursement for vocational horticulture for 1972–1973 was $195,500. Utilizing the feeder high school print shops for printed materials saved money as well. In the last years of the program, tract superintendents were made to take on a heavier load, supervising more than one tract.

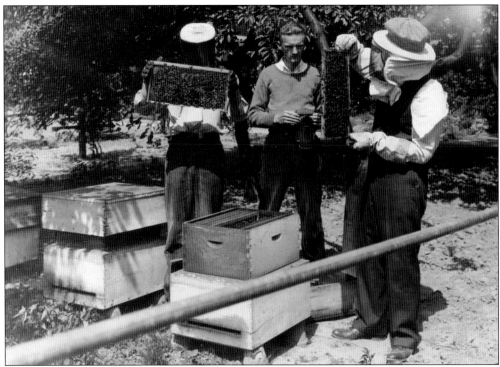

What would a garden be without bees? Beehives at West Technical gardens, seen here in 1937, were used as a pollination lesson. The superintendents took charge of the hives themselves. The kids were fascinated with the hives and of course the honey. The honeycombs were taken into the classroom to show how the bees constructed their hives.

These two industrious gardeners are making a butterfly feeding station. Garden students were always encouraged to do things for themselves. Part of the objectives of the tracts was to develop better work habits through active work-assignment projects on the school grounds or in their neighborhood.

These anxious third graders are watching the garden custodian put the final touches on the butterfly feeder. The kids were encouraged to look for beauty in nature. What was more beautiful than a butterfly in a well-kept, productive garden?

These student gardeners are weaving a straw blanket for ground cover. The gardens were established in the last analysis to develop a basic understanding of ecology with specific emphasis on the importance of plants in the environment.

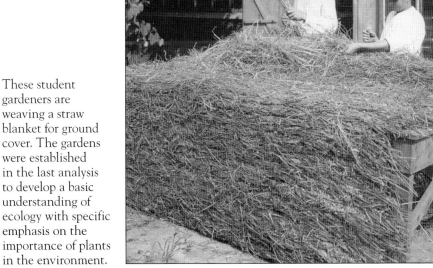

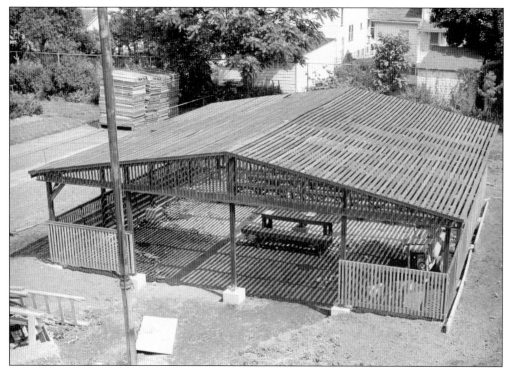

The shaded wooden structure was used for picnics and science classes at Harvey Rice tract garden. This was a great improvement over the tent with wooden seats that was used in the first 30 years of the garden. This structure was built alongside the new greenhouse. Constructed in 1938, the garden building, coupled with the new greenhouse and shaded picnic area, made the garden complete. Commercial nurseries would have been envious of the Harvey Rice gardens.

This is an example of staging the garden harvest by an individual group from a school for the garden open house. The students are from Audubon Junior High School. Each year the students would have a chance to compete for the best garden produce at the individual tract garden. This 1953 display in the Harvey Rice Crawford memorial garden shows how creative the displays could be.

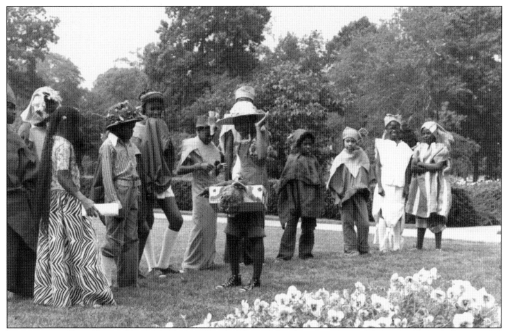

It was not all work in the gardens for the children. Garden superintendent Les Beamish was the unofficial cameraman in the 1970s. Beamish took a picture of Dr. Ed Johnson's group of garden actors in the Miles Standish tract garden. They were called the Miles Standish Players in 1976 at their children's garden fair. The kids would put on plays like "The Wizard of Gardens."

The peanut scramble was one of the picnic games the students enjoyed on their open-house day at Harvey Rice Garden, keeping the peanuts they gathered as a reward. The day would begin with a parade followed by inspection of the gardens by the parents, games, and then a wiener roast.

Children line up at the Harvey Rice garden to get some treats, which were sometimes something as little as a cookie. The children really seemed to be enjoying themselves as they ham it up for the camera.

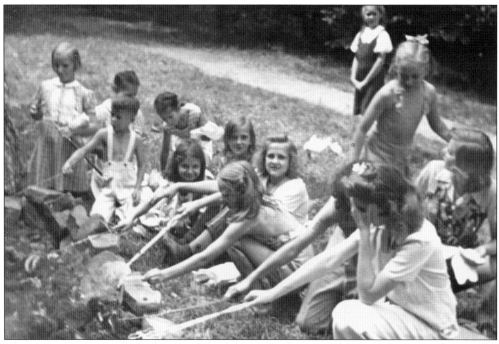

The wiener roast was the highlight of the day. Under the watchful eyes of their mothers in the right foreground, the children enjoy the roast. Sometimes the gardens would put on picnics during the summer just to keep the children's interest. The parents and garden teachers would share the cost of the wieners and all the fixings.

Four

GARDEN TEACHERS
AND ADMINISTRATION

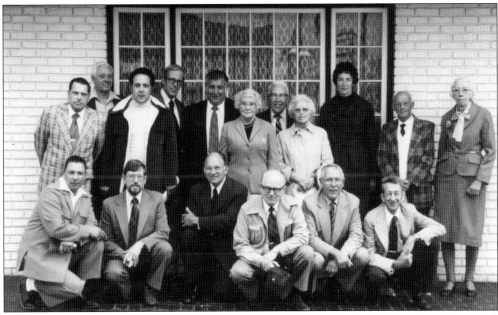

From its beginnings at the turn of the century, the Cleveland tract garden program was administered by dedicated and hardworking people. The faculty group shown here was instrumental in keeping the gardens open during its last years in the 1970s. From left to right are (first row) Nicholas Paserk, Dr. Peter Wotowiec, Arthur Riebau, Jack Durell, Darian Smith, and Luther Karrer; (second row) Richard Vainer, Les Beamish, Albert Mazzeo, Eliot Paine, Thomas Gaetano, Mildred Smith, Paul Young, Sylvia Young, Irma Bartell, Rudy Hozheimer, and Frances Zvrina.

This 1955 photograph contains images of the most important names in the history of the garden program. The closest thing to founding fathers were Dr. Edward Johnson, Luther Karrer, and Herbert Meyer. Although they were not old enough to witness the first harvests, they came on to the scene in the early 1930s. One person who is noticeably absent from the photograph is Paul Young, who was probably the photographer. Pictured from left to are (first row) Kenneth Parker, Joseph Brosch, Frank Kukowitch, Arthur Riebau, Luther Karrer, Walter Herisch, and Herbert Meyer; (second row) Chris Suering, Dan Stephan, Dr. Edward Johnson, James Smith, Carlton Jenkins, Vince Fick, and Meryl Cooper; (third row) Nicholas Paserk, Jack Durell, and Thomas Gaetano; (standing) William Davis.

An unidentified teacher is at the microphone at a Harvey Rice student garden fair. Paul Young has his back to the camera. The whole student body of Harvey Rice Elementary School would turn out for the festivities. The fair would be held in the Crawford Memorial sunken garden next to the school. Each classroom had assigned seating. The kids would be called up individually to receive their ribbons and certificates. Young was second in command to Herbert Meyer, supervisor of the school gardens.

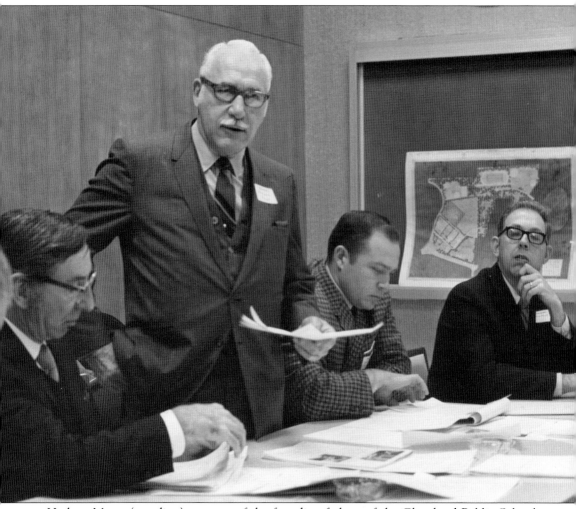

Herbert Meyer (standing) was one of the founding fathers of the Cleveland Public Schools horticultural program, and he supervised the garden tracts for many years. He is seen here conducting the Washington Park Advisory Committee. From left to right are John Davis, Herbert Meyer, Vince Feck, and Eliot Payne. This was the steering committee for the introduction of the vocational horticultural program at Washington Park.

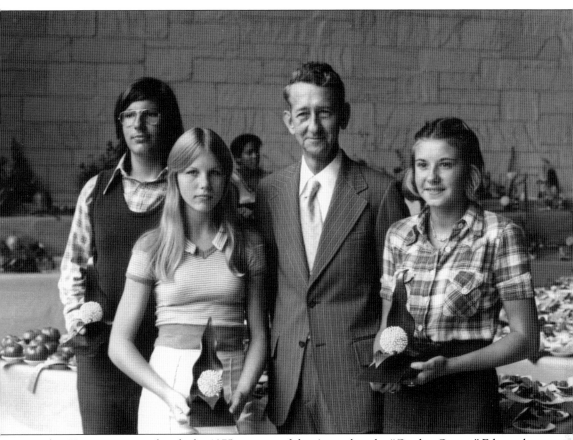

Luther Karrer is pictured with the 1975 winners of the Agricolas, the "Garden Oscars." Edmund W. Gardias, Missy Radish (center), and Janice Artbauer won this top award from a field of over 2,000 student gardeners. Karrer taught horticulture in the Cleveland Public Schools for 35 years before retiring in 1974. He grew up on a farm and received his horticultural degree at Ohio State University. Karrer went on to get his master's degree in education. He worked at Memorial, Henry W. Longfellow, and Harvey Rice tracts. He also supervised the adult home garden program. During World War II, he served with the army in the Philippines, and toward the end of his tour there he grew vegetables for hospitals.

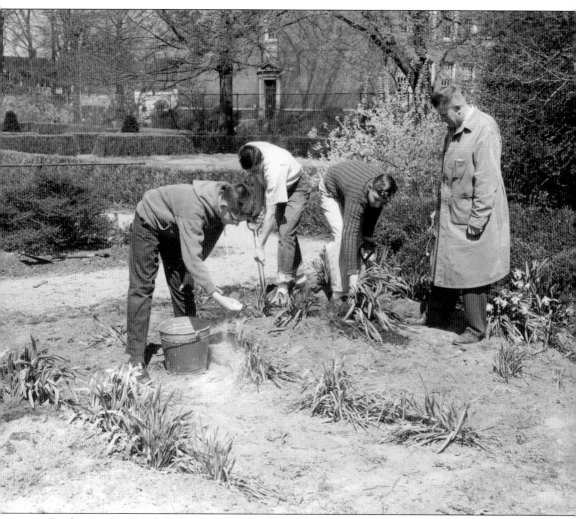

Garden teacher Frank Kukowitch watches over his charges at Benjamin Franklin tract garden. Kukowitch became tract director in 1950, and he taught junior high students at Franklin. The garden subject was officially known as horticulture under Kukowitch's tenure. He taught the first comprehensive program for primary students that included kindergarten classes. It was a spring program just for Benjamin Franklin students. From a mimeographed history of Benjamin Franklin garden, "With the increase of so many students participating, summer garden tract teachers were brought in for organizing and teaching. Some of the first teachers were Miss Schraegle and Dorothy Telling. Other teachers were Alfred Aiello (1950–1951), Richard Codispoti (1951–1962). Rudy Thiel (19- to 1971), Michael Sirok, Ann Zelinski (1963), Victor Svec (1956–1966), Carl Svec (1974), and Thelma Dudek (1964). In 1968 when Carl Schusterman came, the horticultural classes were changed to vocational horticulture. He taught at Benjamin Franklin until the spring of 1975. Teachers who also taught this subject were William Zmich, (1973–1974), and Kris Krems, (1975–1977). Joanne Scudder started teaching in the fall of 1974. Diane Feichtmeir started teaching in the fall of 1977."

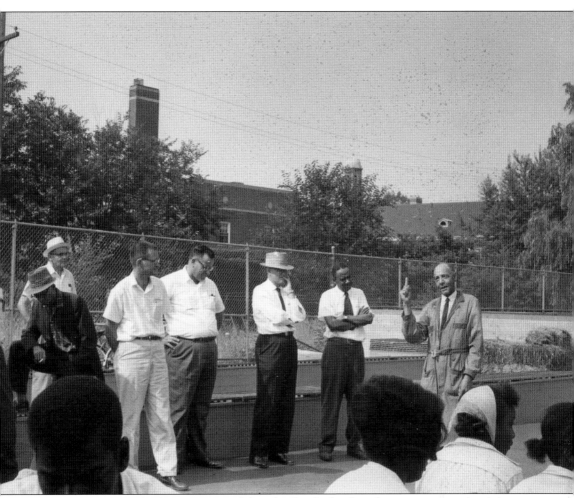

One of the remarkable characteristics of the Cleveland school garden program was the ability to attract the best horticultural educators. Dr. Edward T. Johnson, native of Cadiz, Ohio, earned both his bachelor's and master's degrees from Ohio State University and obtained his doctorate in education at Case Western University. In 1959, he designed the garden at Miles Standish School. Dr. Johnson was also director of Eliza Bryant Nursing Home tract garden. Johnson came to Cleveland in 1936 to teach landscape gardening at the old Outhwaite Occupational School for Boys. He was assistant principal of the school when it was converted into a Cleveland elementary school in 1943. Johnson taught horticulture at East Technical High School. He was appointed director and coordinator of all inner-city public schools' garden programs. Dr. Johnson wrote many articles for the local newspapers. In this July 1963 meeting, Dr. Johnson is making a point to his fellow garden supervisors, parents, and students.

Nicholas Paserk devoted 40 years of his life to the children of Cleveland Public Schools as superintendent of many of its tract gardens. He was garden superintendent at Harvey Rice, Miles, and Benjamin Franklin tract gardens. In the last days of Benjamin Franklin garden, Paserk supervised 450 primary gardens and plots and 100 kindergartner plots. There were 450 individual garden plots for the summer tract program, and 25 schools in the Benjamin Franklin area were involved.

Pictured in 1963 are Peter Wotowiec (left) and Ken Parker at Longfellow tract garden on the city's northeast side. Both teachers started their careers as tract garden students. Wotowiec would become the Cleveland garden program's director in the 1970s. In the early 1970s, he received his doctorate from Ohio State University. Ken Parker became superintendent of Miles tract garden.

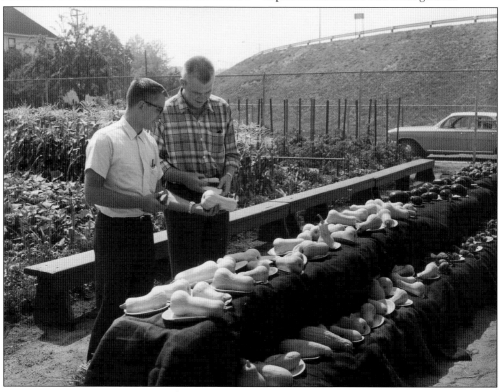

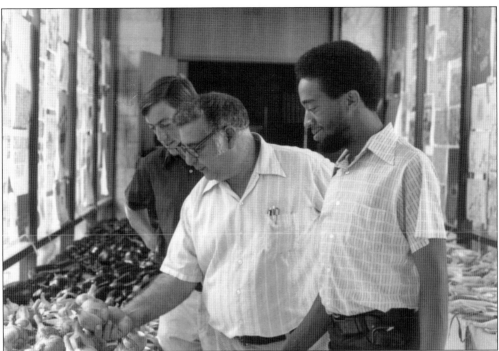

From left to right, Thomas Patric Hassey (laborer at R. G. Jones Garden), Tom Gaetano (teacher), and Harold Arnold (summer garden teacher) are at one of the children's garden fairs at the Cleveland Botanical Gardens. Gaetano's job was the planning of schoolyards throughout the system and coordinating the Youth and the Environmental Action Program. Harold Arnold later became assistant superintendent of an educational cluster.

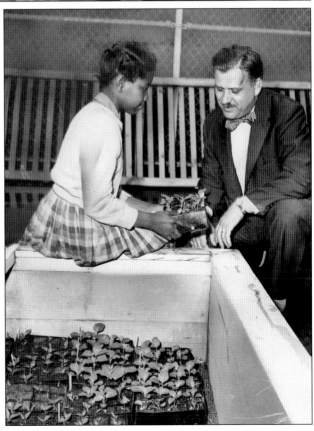

One of the many unsung heroes of the horticulture program is Charles Mihalko, science teacher at Miles Standish Elementary School. Mihalko is instructing 11-year-old Linda Magee in the art of transplanting. Part of the students' grade would be how well they did in their garden projects.

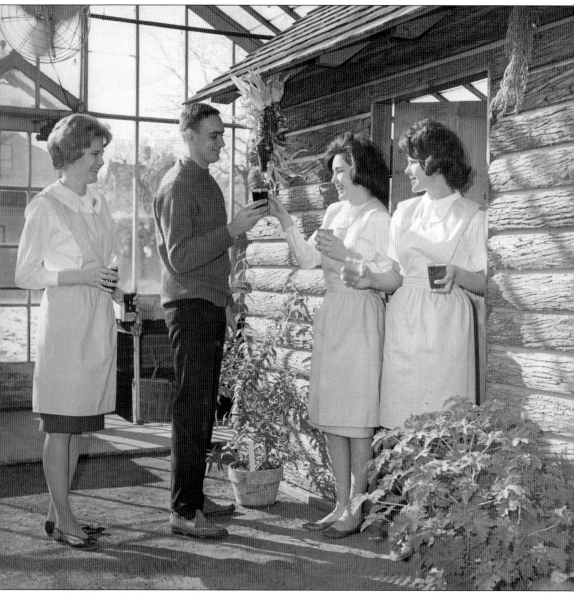

Herb jellies made by West Technical High School students go into the log cabin and herb garden setting that is the Home and Flower Show contribution of the Garden Division of the Cleveland Board of Education. The culinary students are Judy Hynek, 18 (left); Darlene Stanley, 16; and Marlene Cogar, 17 (right). Dave Stephan, the greenhouse assistant, helps grow the herbs. Stephan later became a teacher in the adult horticultural program and an administrator with the Cuyahoga County Fair. Stephan is presently the president of the Cuyahoga Agricultural Society.

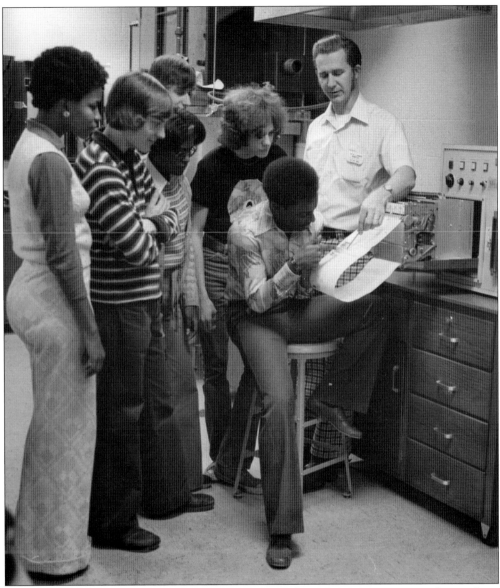

Jack Newmarch, a teacher at Washington Park Horticulture Center, is instructing his students about how to interpret air quality with the gas sampling equipment, such as the Techicon II Air Sampler. The Techicon II is used to analyze sulphur and nitrogen in the air. Newmarch's program was called environment management, and students were recruited from Cleveland's South High School. They took classes that combined material from horticulture, chemistry, biology, meteorology, bacteriology, physics, and some mechanics and engineering. Topics of study included ecology, air and water pollution detection, monitoring and treatment procedures, waste treatment, water purification, effects of weather and air pollution, esthetic and soil pollution, disease, pest identification, and environmental control effected by federal, state, and local governments. It will never be known what modern developments would grow out of this research. The Cleveland garden program was right on the edge of all the modern developments in environmental studies. This picture was taken on January 24, 1977—the last year of the full-scale garden program. The tract garden experiment that had lasted 74 years abruptly ended.

Paul Young, who lived for 108 years, was eight years old when the Cleveland tract garden program began. When he was 18 in 1913, West Technical High School had been open for a year. Tech's garden building and greenhouse were built, and a small experimental garden was started. Young was around from the very beginning and lived to see the end, giving his life to the kids of Cleveland. In addition to his work as a horticulture teacher and supervisor, Young wrote extensively on horticulture. He wrote the gardening textbooks *Elementary Garden-Graphs for Boys and Girls, School Gardengrams* and *Advanced Garden-Graphs for Boys and Girls, School Gardengrams* for the National Garden Institute and was a garden columnist for the *Cleveland News* and *Cleveland Press.* Young was the head of the Cleveland school garden program for years, bringing it national recognition. In the end, he was recognized as the most outstanding school garden consultant in the United States.

Five

HARVEST AND AWARDS

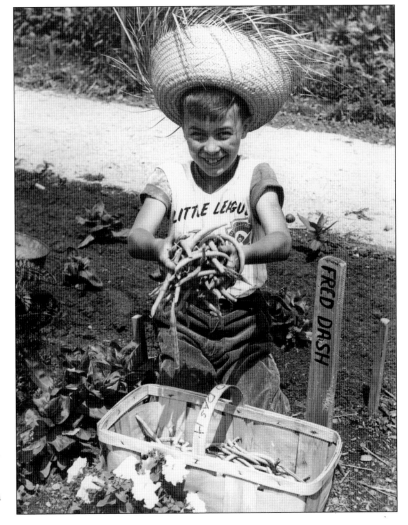

Fred Dash, age 10, had just finished harvesting beans from his student tract garden at Benjamin Franklin School when this photograph was taken. In 1961, Fred lived at 4524 Broadview Road in southwest Cleveland. Fred was a member of the Plain Dealer Green Thumb Club. Notice the stakes next to the little gardener. Thousands of board feet of wood were used each year to mark the boundaries of each student garden.

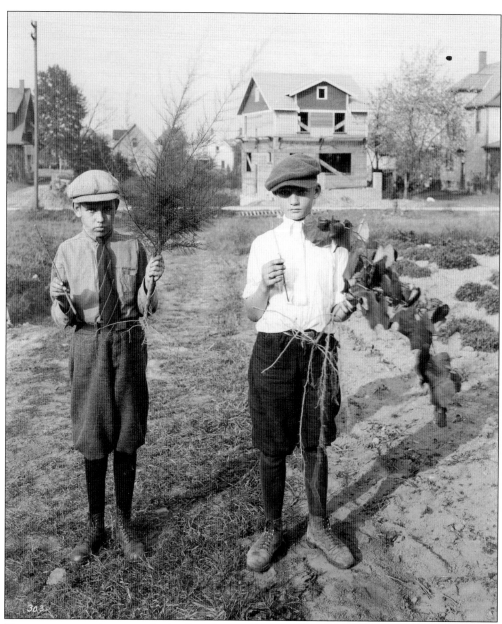

Here are two proud owners of a shrub and a squash plant. Close examination of their right hands reveals starter cuttings for the plants. These early-1920 gardeners, in their knickers, are illustrating how to start a plant from cuttings and the end results. The whole idea of the garden program was to prepare the gardeners for life and citizenship by creating a love for beautiful things, fostering a joy in the care and propagation of plants, building and maintaining better habits of health, improving mental health, giving a better understanding of the world food problems, and teaching conservation—vitally important to the strength and prosperity of the nation. Paul Young wrote, "Activity and work experience, now recognized as fundamental in learning, can be provided through gardening more readily and inexpensively than almost any other way. The educational value of gardening, as a means and motivation for learning in almost the whole range of school subjects, is outstanding."

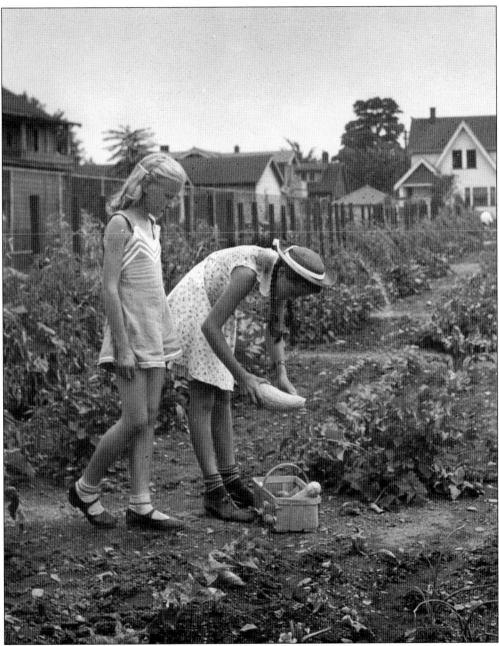

These girls are admiring the fruits of their labor, with a thrill of the harvest as old as mankind. Multiplying this simple scene by tens of thousands hints at the impact that the Cleveland garden program had on the youngsters of Cleveland. The program was not a haphazard endeavor. The number of hours planning and nurturing of the tract garden concept is beyond count. The dedication of the garden teachers and staff has not been duplicated anywhere in the nation. Every day, small miracles of self-realization would poke through the dirty, yet smiling, faces of the children. They realized that they could follow a plan and see a living thing grow before their eyes. They knew with first-hand knowledge what it took to grow a garden. The mantra of the Cleveland garden program was "Children grow in gardens."

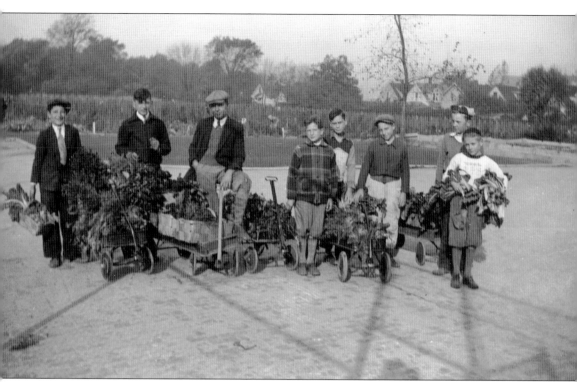

The wagon train full of produce is ready to be shipped home. This early-20th century scene captures the essence of the school gardening experience. The kids had a product to show their parents. The boys on the left, dressed in coats, shirts, and ties, are upperclassmen. The boys on the right are obviously not. The one thing that united them was the gardens. It was not uncommon for the children in the families to hold the same garden plot generation after generation. Mothers could be heard in the echo of time saying to the boys, "Go to the garden and pick some lettuce for tonight's supper." During the Depression years, families relied on the gardens to get by. The last chance Cleveland schoolchildren had to experience how vegetables came to be on their tables happened over 30 years ago.

Recognition programs were an essential part of the tract and horticultural programs in Cleveland. At the tract gardens, the produce was judged and awarded certificates and ribbons at harvest time. At the schools, award assemblies were given in the autumn months. The home gardeners were judged by garden teachers, and the winners were a part of the general all-school's garden fair. Throughout the years, the garden fair was held in various locations, such as the Higbee Company and the Cleveland Botanical Garden Center. The sponsors of the programs were the *Plain Dealer*, the Cleveland Botanical Gardens, and Higbee, a local department store. This photograph shows a horticultural assembly awards program on the Higbee's stage. The master of ceremonies and director of the awards program was Luther Karrer, who taught horticulture and tract gardening in Cleveland Public Schools for 35 years before retiring in 1974. Karrer died of cancer two years after the closing of the gardens.

Many important administrators and politicians were present at the first Children's Garden Fair at the Greater Cleveland Garden Center on September 18, 1966. The adults in the center of this photograph are, from left to right, Paul W. Briggs (superintendent of the city schools), James A. Rhodes (governor of Ohio), and Ralph S. Locher (mayor of Cleveland). Ohio Supreme Court judges Paul W. Brown and Louis J. Schneider Jr. were present, as was Herbert G. Meyer, who headed the horticulture division of the Cleveland schools. Mrs. Marie Clark (wife of Harold T. Clark), the president of the center, is standing to the left of the group. The student gardener in the middle of the grouping is unidentified. In the final years of the gardens, desperate pleas were made to Governor Rhodes to save the tract garden program. For whatever reasons, known only to him, the pleas were not heeded and the gardens closed.

BOARD OF EDUCATION, CLEVELAND, OHIO

DIVISION OF SCHOOL GARDENS

This is to certify that JOHN PAVELICH has satisfactorily completed the SEVENTH year of work in Gardening, including a practical garden project, under the direction of the Division of School Gardens, at HARVEY RICE School; in recognition whereof this certificate is awarded this 22nd day of OCTOBER 1959 with a rating of EXCELLENT.

School Leader

Supervisor of School Gardens

Superintendent of Schools

8 John Pavelich

Here is a typical garden certificate issued to a student for excellence in gardening. John Pavelich had gardened for seven years and was one year away from earning a silver medal. At the bottom of the certificate there is a space where multicolored dots are placed next to the gardener's name. The dots signify successful completion of garden projects and perfect attendance. Note that the certificate is signed not only by the superintendent of schools but also by two of the major forces of the garden project: Herbert G. Meyer and Paul R. Young. For kids of the days when there were no distractions by game technology, these certificates were cherished possessions. In 1948, Young wrote, "Prizes, awards, and certificates are presented at special recognition programs held by each garden during late October or early November. These programs end the season with a high note of satisfaction and arouse an enthusiasm for 'next year,' which is typical of gardeners everywhere and of all ages."

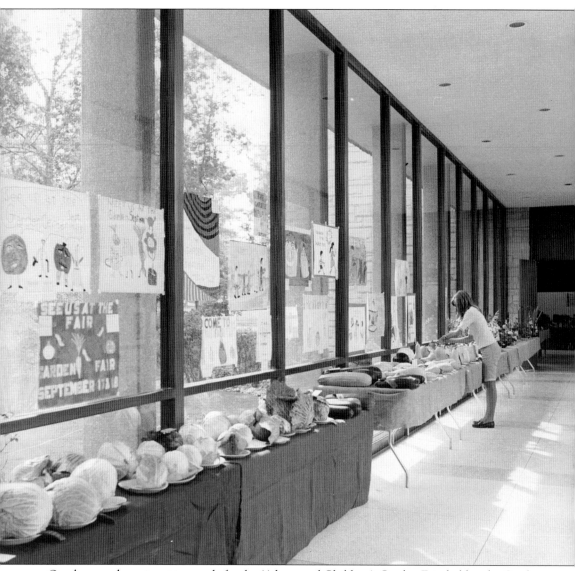

One lone gardener is getting ready for the 11th annual Children's Garden Fair, held at the Garden Center of Greater Cleveland August 28–29, 1976. Exhibits of flowers and vegetables grown by the 2,200 children from 24 suburban groups of schools and 11,800 from 180 Cleveland schools who had school or home gardens were on display. Ribbons were awarded by judges to the most deserving entries of flowers and vegetables. Winners were named for the poster contest (notice the posters on the windows) and the Warren H. Coming Essay Contest. Agricola awards were presented to the top winners in each of five sections—vegetables, flowers, posters, essays, and caricatures. Mrs. Thomas V. H. Vail, the wife of the *Plain Dealer* publisher, was the honorary chairwoman, Mrs. Dudley A. Hawley Jr. was chairwoman, and Luther Karrer was the coordinator.

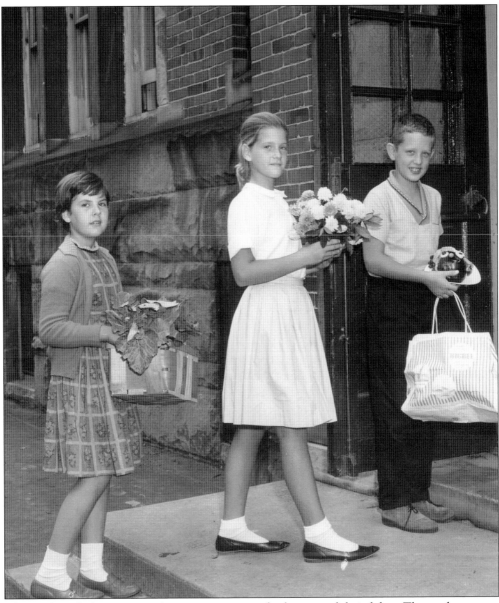

The unidentified youngsters shown are carrying the harvest of their labor. The students were given awards for excellence in gardening. The children are holding the products that represent three of the five categories judged at each school's garden fair. The girl on the left is showing the vegetable category, and the girl in the middle has a floral arrangement. All gardens had a three-foot edge on the center path filled with flowers. Flower arrangement was one of the major components of the horticultural curriculum. The young man is holding a caricature, the shaping of the vegetables into faces and whimsical objects, which was a favorite of the young gardeners. The fourth category was the poster-painting contest (not shown here). The winner of the poster contest would be awarded the privilege of having her or his poster used for advertising the next year's garden show. The fifth category was the essay contest. The essay about what gardening means to each student was usually penned in down time at the garden. A rainy day was great for this task. This photograph is dated September 14, 1962.

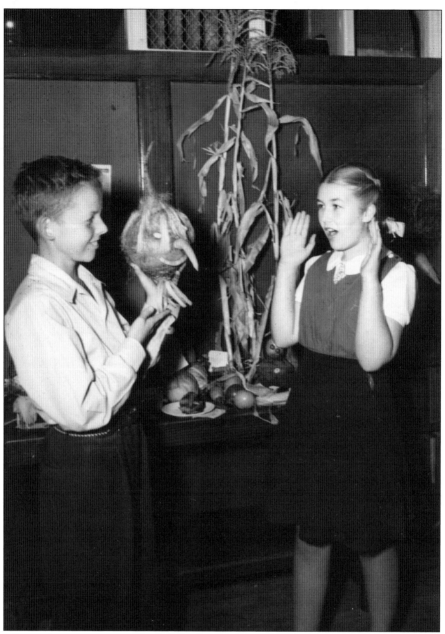

The making of caricatures was a favorite of the young gardeners. They were judged on originality in ideas and execution, but were disqualified if they used manufactured plastic eyes, ears, and buttons. The use of natural or grotesque forms of vegetables and flowers would receive higher ratings than those severely cut or trimmed into shape. The judges loved this category, with many a sidesplitting laugh heard in the halls of the Cleveland Garden Center. Underneath all the fun and suspense of the garden fairs lay the purpose of the exhibitions. They provided a fitting culmination to the home garden season and to recognize the accomplishments of those who had garden projects. They also provided an opportunity for the students to exhibit the results of their gardening efforts. The exhibits at school provided materials for identification and study by science classes.

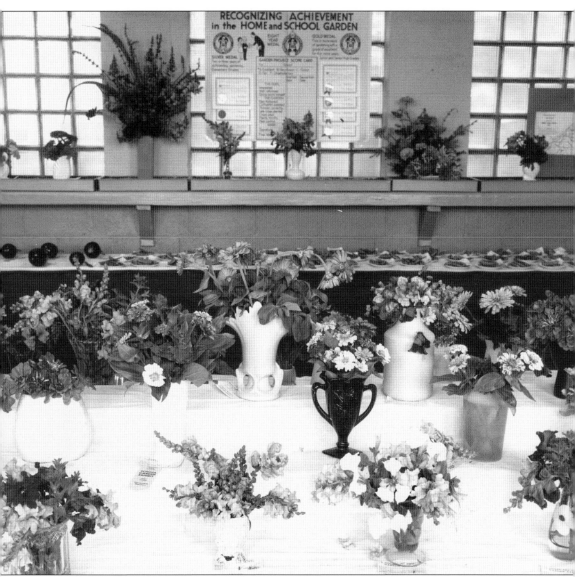

The flower arrangement category was the part of the fair that brought the most "oohs" and "aahs." Even the worst arrangement could be considered beautiful, especially if it was done by a son or daughter. The best of the best went on to the children's fair at the Cleveland Botanical Garden Fair. The flower competition was divided into two categories: flower specimen classes, where individual flowers were judged; and flower arrangements, where flowers and other materials are subordinated to the arrangement as a whole. Often thought of as a girls' category, over the years boys took top honors. The planning and execution of the garden fair gave students an opportunity to develop leadership and exercise initiative in planning and organizing the details of the exhibit. Ultimately the goal of the three types of fairs—the tract garden open house, the individual school honors program and exhibit, and the children's fair at the Cleveland Botanical Garden Fair—was to encourage wider pupil participation in all activities.

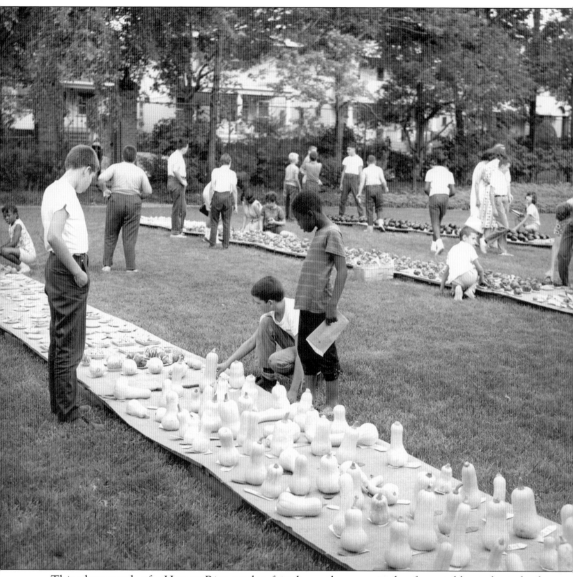

This photograph of a Harvey Rice garden fair shows the magnitude of vegetables to be judged. This "in-school fair" was the last step in the judging of the produce before the winners were sent off to the "big show" at the Cleveland Botanical Garden Center. The judging criterion was not based on a good, better, best, but on a quality scale of excellent, very good, good, and honorable mention. This scale allowed for a greater number of gardeners to receive awards. The vegetable should have a fresh, ready-to-eat appearance. Any blemishes could cost a gardener a grade level. A typical tomato of merit would be of medium size, smooth, uniform red color, and firm and solid. A tomato that had faults would be of irregular or angular shape, over- or undersized, have cracks or corrugations, have green patches, or be soft to the touch.

Six

GARDEN PROGRAM ENDS

The Cleveland school tract garden program began closing in the autumn of 1977 for numerous reasons. The gardens were a good thing for the kids of Cleveland. To this day, if one were to go to a vacant lot that was once a beautiful tract garden and listen, the mantra of the Cleveland garden program can still be heard, "Children grow in gardens."

www.arcadiapublishing.com

Discover books about the town where you grew up, the cities where your friends and families live, the town where your parents met, or even that retirement spot you've been dreaming about. Our Web site provides history lovers with exclusive deals, advanced notification about new titles, e-mail alerts of author events, and much more.

MADE IN THE USA

Arcadia Publishing, the leading local history publisher in the United States, is committed to making history accessible and meaningful through publishing books that celebrate and preserve the heritage of America's people and places. Consistent with our mission to preserve history on a local level, this book was printed in South Carolina on American-made paper and manufactured entirely in the United States.

This book carries the accredited Forest Stewardship Council (FSC) label and is printed on 100 percent FSC-certified paper. Products carrying the FSC label are independently certified to assure consumers that they come from forests that are managed to meet the social, economic, and ecological needs of present and future generations.

FSC
Mixed Sources
Product group from well-managed forests and other controlled sources

Cert no. SW-COC-001530
www.fsc.org
© 1996 Forest Stewardship Council

Find Your Place in History.